MAJESTIKA
THE ART OF
MONTE MICHAEL MOORE

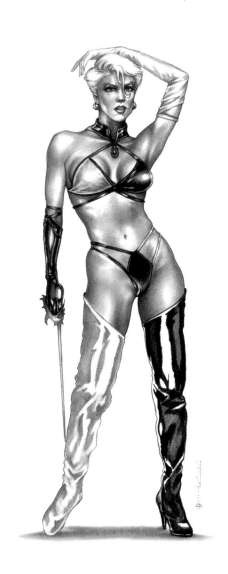

MAJESTIKA
THE ART OF
MONTE MICHAEL MOORE

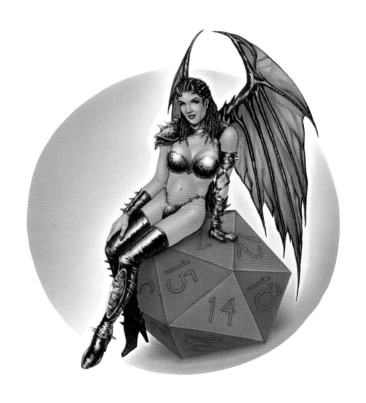

FOREWORD BY
LARRY ELMORE

First published in Great Britain in 2004 by
Paper Tiger
The Chrysalis Building
Bramley Road
London W10 6SP

An imprint of **Chrysalis** Books Group

Distributed in the United States and Canada by Sterling Publishing Co., 387 Park Avenue South, New York, NY 10016, USA

1 3 5 7 9 8 6 4 2

British Library Cataloguing-in-Publication Data:
A catalogue record for this book is available from the British Library.

ISBN 1 84340 185 1

Commissioning Editor: Chris Stone
Project Editor: Miranda Sessions
Designed by: Paul Wood
Edited by: Paul Barnett

Reproduction by: Classic Scan Pte Ltd, Singapore
Printed and bound by: Imago Productions, Singapore

Visit Monte Moore's web site at http://www.mavarts.com.

For Laura, for her constant love and support of my eccentric habits and artwork . . .
. . . and for Frank Covino, teacher and inspiration —
thank you for opening my eyes.

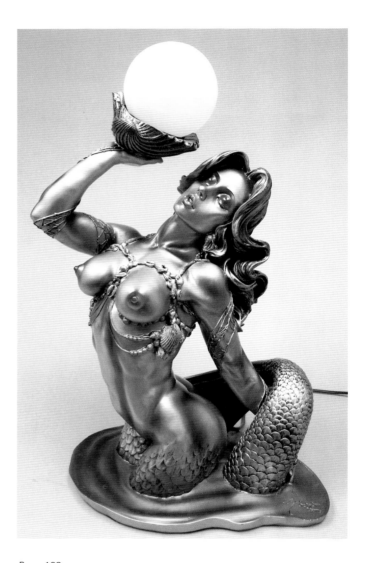

Half-title page:
DOMINO EFFECT
This is a pin-up of Janu, the lead character of 'BloodLines' — my first and only illustrated graphic story, which can be found in the back pages of this book.

Title page:
DICE DEMON
Colour logo done for Chainmail Bikini Games, an RPG publisher. Care to roll the dice with her?

Page 128:
HOT ICE
Model: Krisha Glenn
This image was painted directly onto the deck of this unique snowboard. This was a Valentine's Day present for the owner from his wife — the model.

Copyright page:
SUNSATIABLE LAMP
Based on World Fantasy Art Show award-winning drawing.

Contents page:
VAMPIRE'S KISS
CCG art for Vampire: The Eternal Struggle.

CONTENTS

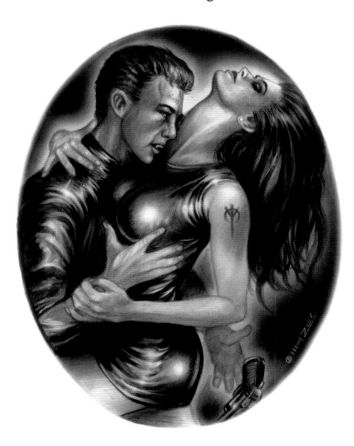

FOREWORD

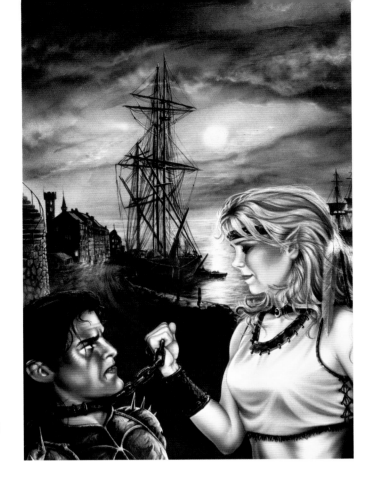

REBELS & TYRANTS
Cover for a Dragonlance novel published by TSR.
My second novel cover, this piece shows more hand-painting and less airbrushing than my usual covers.

A round six or eight years ago, while attending a convention, I encountered an artist I hadn't met before. This young man came up to me, said a few words and shook my hand. He had a flashy smile and was very forward and confident. He was just too cool, so I automatically thought he probably couldn't draw crap! Yep, just another young artist trying to make it in this crazy business. He introduced himself as Monte Moore. Little did I know that in a few years he would save my life.

Well, this young cool dude with the big flashy smile and the air of confidence wasn't just talkin' the talk, he could walk the walk. We chatted a little and he gave me a poster calendar featuring his work: drawings of beautiful women. I believe drawing is the foundation for a good illustrator – and, man, this Monte Moore guy could draw! I brought the calendar home with me and put it on the wall in my studio – I needed a new calendar anyway. It stayed up all that year, and the next, and the next and the next. People visiting my studio would remind me that my calendar was around three or four years out of date and tell me I needed a new one. My reply was always the same: 'Yep, I know, but I like the art.'

What can I say? Monte Moore is a good solid artist. Every time I see his new work, it's just getting better and better. You will find that out for yourself in this book.

But what this book will not show you is what an all-round great guy Monte Moore is.

After meeting him that first time, I started running into him every now and then at different conventions, and I finally got to know him as a friend. We not only had art as a common interest, we shared a love for motorcycles and fast cars with big engines.

About three years ago I was staying at Monte's house in Colorado for a few days. During the week I had noticed a deep burning sensation in my upper back and chest, but we were

having a great time and so I just tried to ignore it. He was showing me the city, Denver, and on Saturday we went riding around town on a couple of his many motorcycles. We had a great day, but that night, in spite of all the fun we were having, I was still feeling poorly.

In the middle of the night I woke up with a full-blown heart attack. Because I had experienced one before I knew, if I didn't get to a hospital quickly, I'd be a goner! I knocked on Monte's bedroom door and told him I was, like, kind of having a heart attack.

Man, I have never seen a guy move so fast in my life. He was dressed and we were in his car in less than three minutes. Within a further few seconds we were shooting through the streets of Denver at eighty plus mph! I was in severe pain but, hey, it was still fun.

We were shooting through a subdivision and going around a curve when Monte uttered a curse. I knew then we were taking the curve too fast . . . His car started to slide sideways, and then, as if we were in slow motion, around we went. We did a one-eighty right down the middle of the street and never touched a single thing. I just saw houses and parked cars flashing by in front of me.

Then, at last, we stopped. The night was quiet, the engine was dead and all I could smell was burnt rubber. Monte fired the car up and floored the pedal again. I told him that, if I weren't hurting so bad, this would be one of my all-time favourite car rides! He just replied that he wasn't gonna be the guy who let me die.

And he was true to his word. He got me to the emergency room and stayed with me throughout the ordeal.

He is a true friend. We stay in touch and see each other every year, at conventions or at our homes.

So here's to you, Monte. May you have many fun and exciting years ahead, and keep giving us more great art!

Elmore

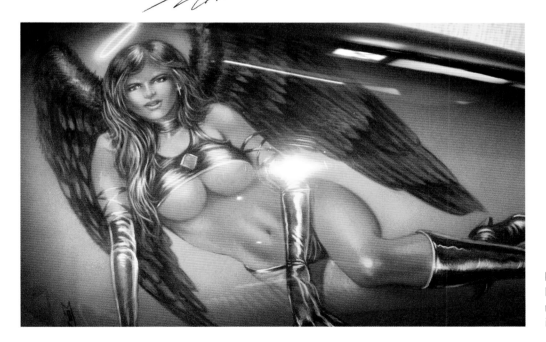

NIGHT WINGS
Harley-Davidson motorcycle tank mural, my second such illustration on metal.

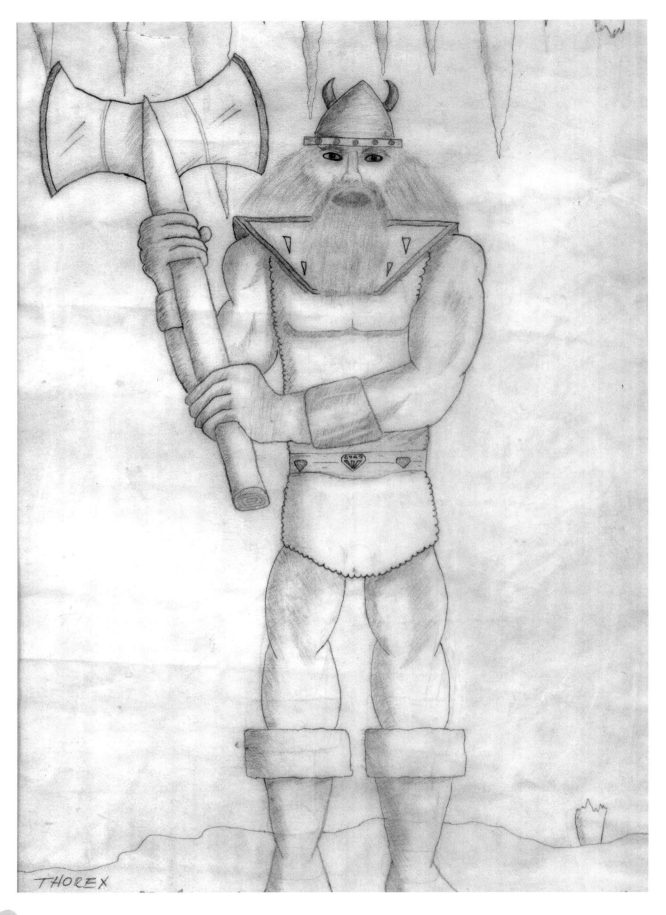

A WORD FROM THE ARTIST

Welcome to another journey into my imagination, art and thoughts. I hope to provide insight and inspiration to those who seek them, and intriguing artwork for those who bought this book just for the 'pretty pictures'.

I was born in 1971 in Phoenix, Arizona, the youngest of four boys. In 1979 we moved to Idaho to pursue cattle ranching, something my family has been involved in for many generations. I spent summers on the family ranch, riding horses, herding cattle, fixing fences and working in the alfalfa fields. As my father used to say, 'Build a fence, build character.'

In the 1980s my overactive imagination found an outlet in TSR's Dungeons & Dragons. I became interested in art, dragons, video games and every sort of role-playing game on the market. I learned to paint lead figures, draw character sketches, and so on. In this I had the support of my mother, herself a very accomplished fine art painter, jeweller and graphic designer; she was always ready to offer valuable critiques. Every month I looked forward to the new issue of *Dragon Magazine*, hoping for new fantastic art from fantasy greats like Larry Elmore, Clyde Caldwell, Jeff Easley and Keith Parkinson. I seldom read the articles – I was mostly interested just in the art.

A strange thing happened one day in high-school art class. Since the age of about six I'd wanted to be a surgeon, perhaps a strange occupation for someone to choose so young. Now I made a decision that would change my life forever: I determined to follow my passion for art. I am eternally grateful I made this decision, and have never since regretted the path I chose. 'Follow your passion. You never know where it might lead . . .'

FROST GIANT *(left)*
I show this drawing, which I did when I was aged 13, as a not-so-fine example of my childhood work. It illustrates my point that being an artist is often the progression of learned and applied skills. We must acknowledge where we came from.

We humans use many things to define ourselves. Often it's the music we listen to, the clothes we wear or the car we drive. For me it was the art I created. I was not an athlete, a musician or an academic, I was the artist. I enjoyed that label very much. It was something to hold onto, something that drove me to create new art to impress people, and something to be very proud of. That can be a double-edged sword, of course, as every piece of art is open to being critiqued — and usually is! Fortunately for me I had very supportive parents, something many youthful artists don't have. I can't tell you how many people I have met who lacked that encouragement, who weren't allowed to follow their dreams to become an artist.

Much of my early high-school work was inspired by or copied from the artists I've mentioned. I know a lot of people say all fantasy artists today are inspired by Frank Frazetta, but I wasn't one of them — not because I didn't like his work but because I wasn't exposed to it. Many of my inspirations are a bit more modern; names like Drew Struzan, Dave Dorman, Hajime Sorayama and Olivia come to mind. Other artistic greats such as Gil Elvgren, Vargas, Norman Rockwell and Michelangelo continue to impact me to this day.

In 1985 my father saw the trends in the beef industry moving towards 'natural' products. He founded a new family business, Maverick Ranch, and in 1989 we moved to Denver, Colorado, a better location for this venture than where we'd been living in Idaho. Moving to a new school and city for my senior year was no picnic . . . but at least I had my art. Most of that year I came home from school, did my homework, and then spent most of my free time drawing or painting (when I wasn't skiing!).

A fateful event occurred that year: I received an airbrush for Christmas!

I would say the large majority of artists who attempt mastery of the airbrush abandon all hope before they ever reach true proficiency. The airbrush is just a tool like any other, albeit a tool with far more moving parts than a paintbrush. Some artists use this tool only for backgrounds or textures, never really tapping its full potential. I did the opposite, becoming so devoted to its use that I tried to paint too many things with it. I wish now I had learned more hand-brush techniques and skills back then rather than relying so heavily on the airbrush. Today I use acrylics (airbrushed and hand-painted), gouache, oils, watercolours and coloured pencils in my paintings, but back then I airbrushed everything! I wanted to be an 'airbrush artist', and was partially defined by that.

I attended Colorado State University in Fort Collins, Colorado, and earned a Bachelor of Fine Arts Degree there. I'm a strong believer in scholarships, and a big fan of other people's money! I earned several art scholarships from high school, as well as federally funded Pell Grants. I even had the opportunity to create international fashion illustrations for the Australian Outback Collection as a high-school senior. Although my parents could have paid for my college, they had chosen to teach their children we should support ourselves and make our own way. Although this was often difficult for me, in hindsight their decision was a wise one, and I'm thankful for it now. I received the highest score possible from the Advanced Placement Art Portfolio review, and was awarded college art credits for the effort. Sometimes you do reap what you have sown.

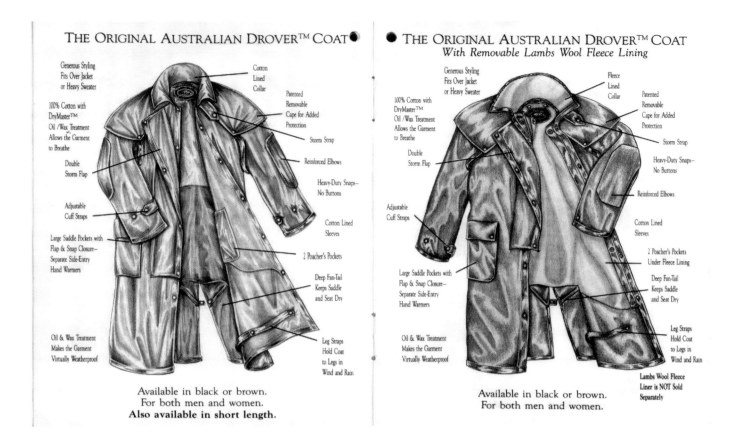

THE ORIGINAL AUSTRALIAN DROVER™ COAT

Generous Styling
Fits Over Jacket
or Heavy Sweater

100% Cotton with
DryMaster™
Oil /Wax Treatment
Allows the Garment
to Breathe

Double
Storm Flap

Adjustable
Cuff Straps

Large Saddle Pockets with
Flap & Snap Closure—
Separate Side-Entry
Hand Warmers

Oil & Wax Treatment
Makes the Garment
Virtually Weatherproof

Cotton
Lined
Collar

Patented
Removable
Cape for Added
Protection

Storm Strap

Reinforced Elbows

Heavy-Duty Snaps—
No Buttons

Cotton Lined
Sleeves

2 Poacher's Pockets

Deep Fan-Tail
Keeps Saddle
and Seat Dry

Leg Straps
Hold Coat
to Legs in
Wind and Rain

Available in black or brown.
For both men and women.
Also available in short length.

THE ORIGINAL AUSTRALIAN DROVER™ COAT
With Removable Lambs Wool Fleece Lining

Generous Styling
Fits Over Jacket
or Heavy Sweater

100% Cotton with
DryMaster™
Oil /Wax Treatment
Allows the Garment
to Breathe

Double
Storm Flap

Adjustable
Cuff Straps

Large Saddle Pockets with
Flap & Snap Closure—
Separate Side-Entry
Hand Warmers

Oil & Wax Treatment
Makes the Garment
Virtually Weatherproof

Fleece
Lined
Collar

Patented
Removable
Cape for Added
Protection

Storm Strap

Heavy-Duty Snaps—
No Buttons

Reinforced Elbows

Cotton Lined
Sleeves

2 Poacher's Pockets
Under Fleece Lining

Deep Fan-Tail
Keeps Saddle
and Seat Dry

Leg Straps
Hold Coat
to Legs in
Wind and Rain

Lambs Wool Fleece
Liner is NOT Sold
Separately

Available in black or brown.
For both men and women.

AUSSIE COATS

My first big commercial assignment, done when I was still just a senior in high school. This 1988 fashion illustration was distributed worldwide, and is still being used in 2004.

In college, I often airbrushed illustrations onto jackets, shirts, helmets and portraits to help pay for my education. Strangely enough I also encountered some adverse bias. When the head of the drawing department saw much of my award-winning high-school portfolio, he informed me that 'the airbrush is not a valid art tool'. I spent many hours in his drawing classes being told I didn't 'live up to my potential'. In retrospect, maybe he was right, but I did my best at the time. I continue to disagree with his negative view of the airbrush, which I feel is as valid an art tool as any other. It's up to the individual artist what he or she chooses to create with the available tools.

Colorado State University didn't offer a degree course in illustration, so I made illustration my own personal focus, applying illustrative approaches to my graphic-design assignments.

A particular event sticks with me even today. One day, while my work was on display in the faculty hallway, a friend came across two of my fellow students critiquing it. Well, that's not quite true. Strangely, they weren't talking about the quality of my work but instead were critiquing me. Although neither student knew me personally, my work and my aggressive attitude towards art were apparently well known in the faculty. The friend who heard these two would-be art critics passed on to me what he said to them in my defence. He told them that what they mistook for arrogance was merely an overabundance of confidence. Through my early accomplishments in art, I had developed a great confidence in my constantly evolving abilities as an artist. But people often mistake someone's confidence in their accomplishments for arrogance. Just because a person achieves success doesn't mean they have an inflated ego.

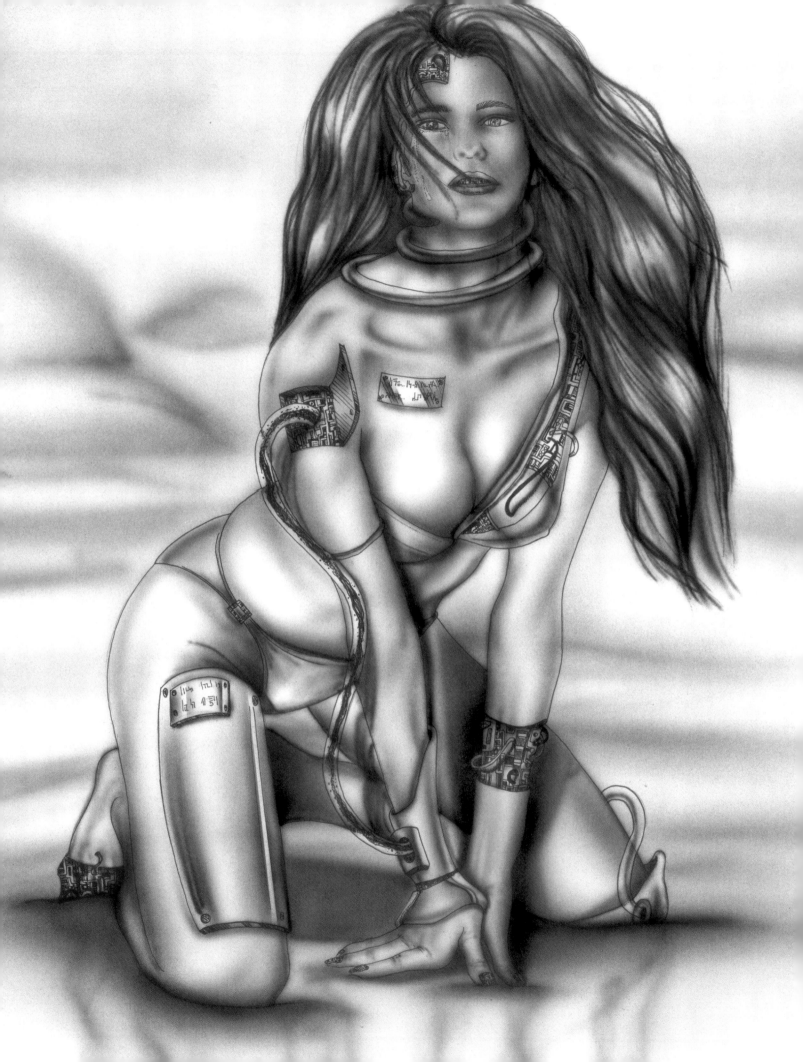

PIN-UP (1991)
Early college pin-up work utilizing pen and ink, with my freehand airbrush style just starting to evolve.

Students and fans often ask me to recommend art schools to them. This is something I will not do. I simply tell them, 'It's not where you go for school that matters, it's what you do while you're there that counts.' I think college forces young artists to experiment with new techniques and media, which is very important. To learn drawing, sculpture, painting and art history can be a great help, but it's up to the individual to produce great art. I could name several successful illustrators who never attended or finished college, and, although I think you should go to college if the opportunity's open to you, you can create masterful visions of artistic expression without a degree in art.

As my time at college neared its end, I had a rather major decision to make: Los Angeles or New York? Which of these two hotbeds of illustration should I choose? As a small-town boy still not accustomed even to Denver, I found neither choice appealing.

As fate would have it, around this time I attended a meeting of the Junior Art Directors' Club of Denver at which new officers were being elected. Only one person was running for the office of President. As a strong believer in democracy, I hated the idea that no one would run against her, so I decided to do it myself. Without any speech prepared, I got up and did an impromptu presentation on who I was, where I had gone to school, what awards I had won, and my clients and achievements. I was extremely happy with the outcome of the voting – not because I won, which I didn't, but because I lost by only one vote despite my lack of previous preparation. That result made me feel confident I could talk to people and convince them of my qualities; if you feel you can do that, you can market yourself.

Going to college is not just a matter of learning more about art, it's one of learning skills such as mathematics, English and speech. Other benefits include marketing classes, business classes, history classes and especially art-history classes. All these skills can be factors, later on, in making the difference between a successful artist and an unsuccessful one. At that Art Directors' Club meeting I was using skills I'd never thought I would have needed. Getting an education exposes you to a world of knowledge.

One other thing happened at that Art Directors' Club meeting. I recall it when artists who are nearing the end of their college education ask me for advice about where they should go from here. I was trying to decide which of the two coasts I should go to because they were both acknowledged centres of illustration in the USA. The guest speaker that night was from a large cable conglomerate based in Denver. After the meeting I went up to him and asked if there was a need for artists like myself in the Denver area. He replied, 'There's always room at the top' – meaning that, no matter where you go or what your job is, there's always a place for you if you're the best at what you do. That message has stayed with me throughout my career. If there's already someone at the top and that's the position you want, the spot is yours to take if you make yourself worthy of it.

I therefore decided to stay in Denver and contribute to the family business while working as a graphic designer. I did this knowing I would have the freedom to find clients and work on my own outside projects.

Freelance work did not come very frequently in my first two years, but eventually I started

getting more assignments. As my skills built up, one client would lead me to another. It has been a ten-year process to become an active full-time illustrator with a schedule that is often booked two to three months in advance.

In 1993, when I was graduating, I happened to have some friends who were putting together a comic book, *Lords of Light*. They had their own publishing company, Legend Comics, and this was their first venture. I was hired initially to paint the cover, and eventually painted (using airbrush) the whole comic book. We all went that year to our first comic-book convention ever, Comic-Con International. The experience and exposure helped lead me directly down the path I pursue today. When I'd graduated from college I'd had no dreams of working in the role-playing game, comics, science fiction or fantasy art fields. Although that's where my loves were, I assumed I would end up being a commercial illustrator working primarily in advertising. Attending a convention and being exposed to other artists and their work can be a major influence on a young artist – and so it was for me.

Years later I started attending science fiction and fantasy-oriented art events on a regular basis. I currently attend probably fifteen conventions and shows a year, mainly in the United States although sometimes abroad.

Art directors don't often ask me which college I attended because to them it's not much of a concern. The work speaks for itself, and hopefully it will do this eloquently enough that a commercial or private art commission will ensue! Often art directors and the patrons of commissions become your friends; this can be very rewarding, and can lead to many further new friendships and to travel all over the world. Many illustrators don't do the 'convention circuit', as we call it, because of the time it takes you away from their families. I think they're unwise. The travelling can certainly be very gruelling, perhaps requiring a five-thousand-mile road trip in a two-week period if the show schedule is tight. (Taking a plane to attend a show is sometimes possible, but can be a very expensive hassle if you have a lot of work you want to exhibit there, especially when your art doesn't show up on the same flight you do!) If you are up to the challenge, conventions can assuredly be worthwhile. You never know how successful a show will be or whether Hollywood's hottest new directors will come by and ask you to do set designs for their next movie. The costs of not going to a convention, in terms of lost opportunities, could be great, even though of course you'd never know what they'd been.

PENCIL STUDY (1992)
One of my earliest pieces of pin-up art to feature pencil work. Although my style took years to develop, and I hope is still doing so, this early piece shows my love of the pencil starting to manifest itself. I remember working on this during economics class – it raised a few eyebrows!

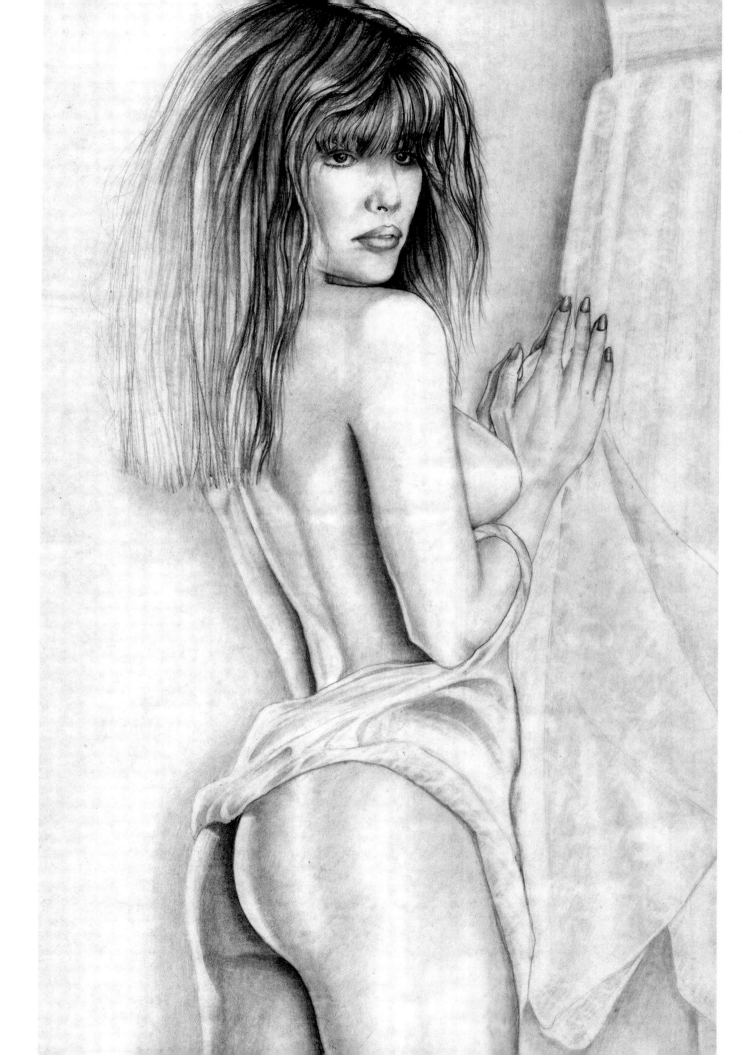

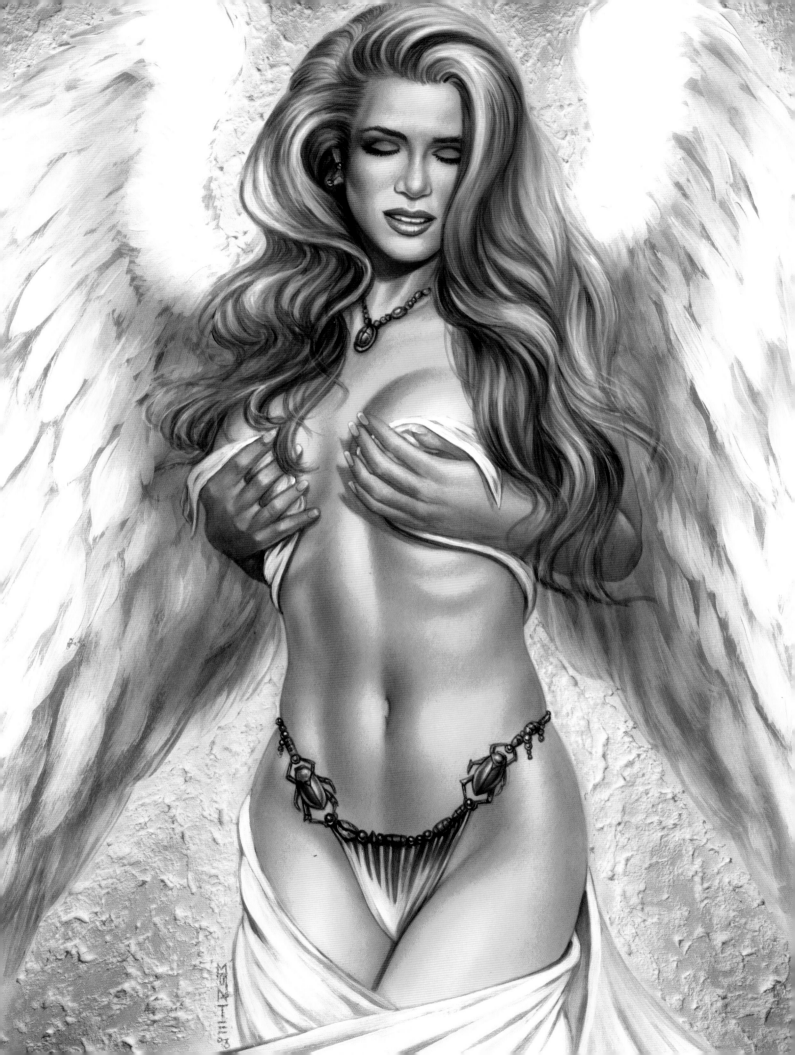

MAIDENS

ANGELIKA *(above)*
This sketch shows the detailed underdrawing I did before starting to paint. A high level of detail and shading at this stage help strengthen the overall feel of the finished portrait. This pose can be seen in my earlier book *Maginique*, where I made it the basis of a mermaid picture. Later I used it for this angelic painting instead.

ANGELIKA *(left)*
Model: Amber Smith
Acrylics on board
This piece was the cover art for *Mystica*, my fourth art book. Techniques of note here are the textural applications. I used a texture gel with blended fibres to create the background effect. A heavy gesso application with a wide brush helped create the desired softness in the wings.

AQUARIUS *(right)*
Model: Veronica Zemanova
This watercolour has a bit of airbrushed acrylics over the initial paint application to smooth out the skin tones. I used gesso with marble dust on the clothing for an added element of depth.

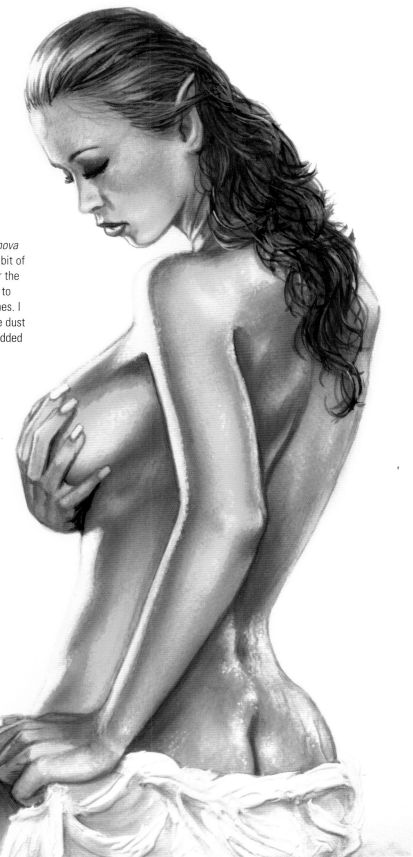

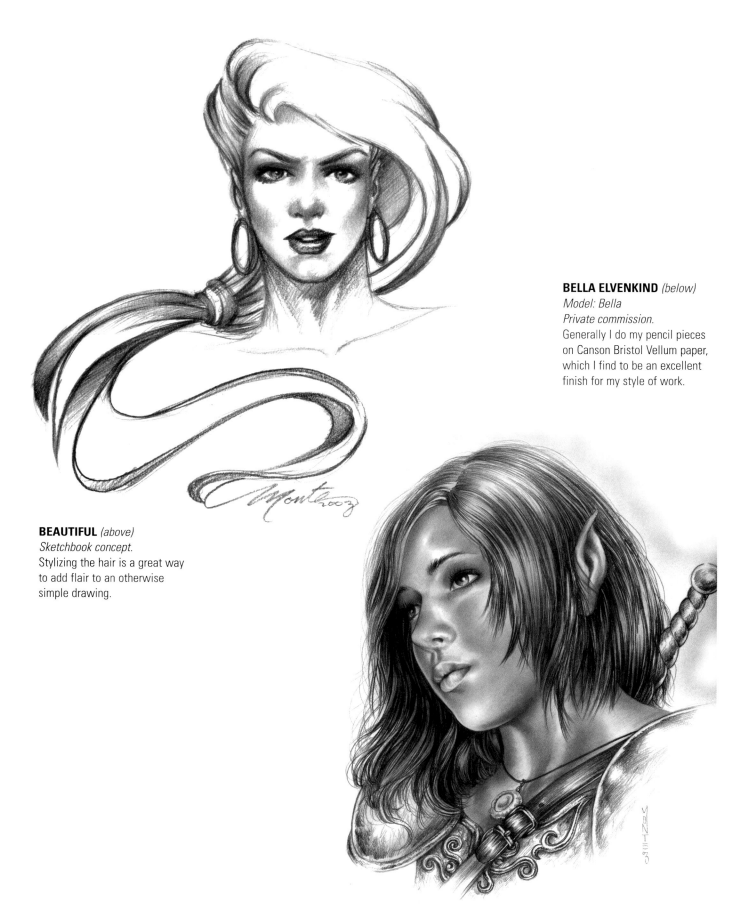

BELLA ELVENKIND *(below)*
Model: Bella
Private commission.
Generally I do my pencil pieces on Canson Bristol Vellum paper, which I find to be an excellent finish for my style of work.

BEAUTIFUL *(above)*
Sketchbook concept.
Stylizing the hair is a great way to add flair to an otherwise simple drawing.

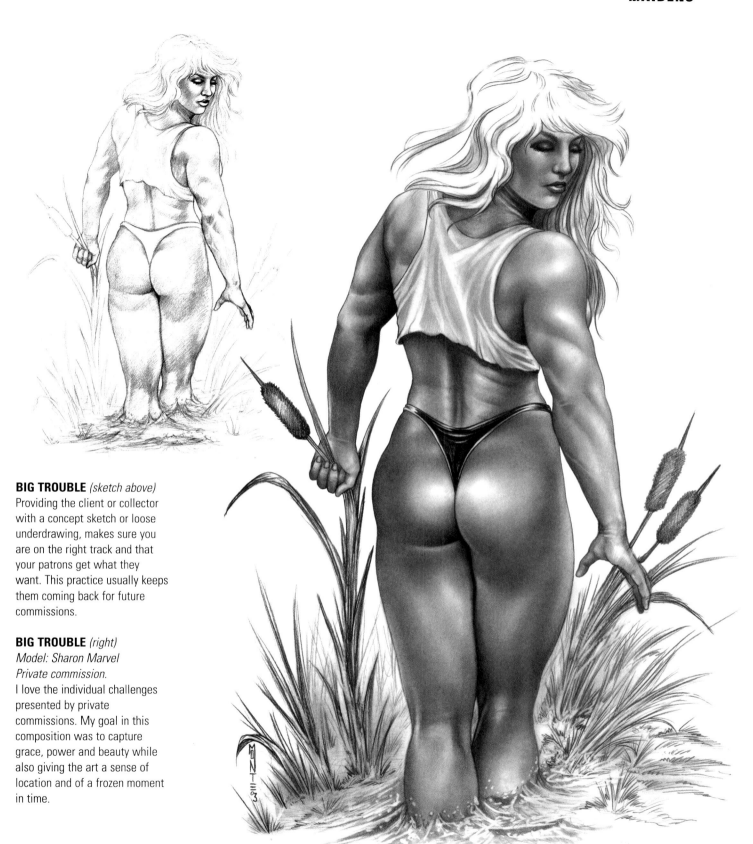

BIG TROUBLE (sketch above)
Providing the client or collector with a concept sketch or loose underdrawing, makes sure you are on the right track and that your patrons get what they want. This practice usually keeps them coming back for future commissions.

BIG TROUBLE (right)
Model: Sharon Marvel
Private commission.
I love the individual challenges presented by private commissions. My goal in this composition was to capture grace, power and beauty while also giving the art a sense of location and of a frozen moment in time.

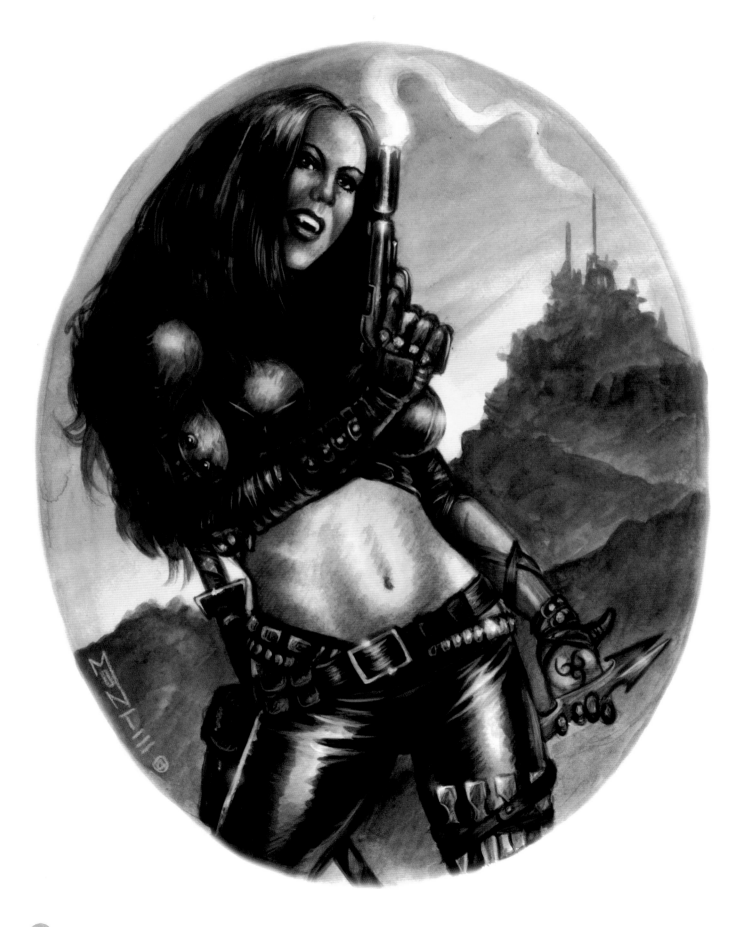

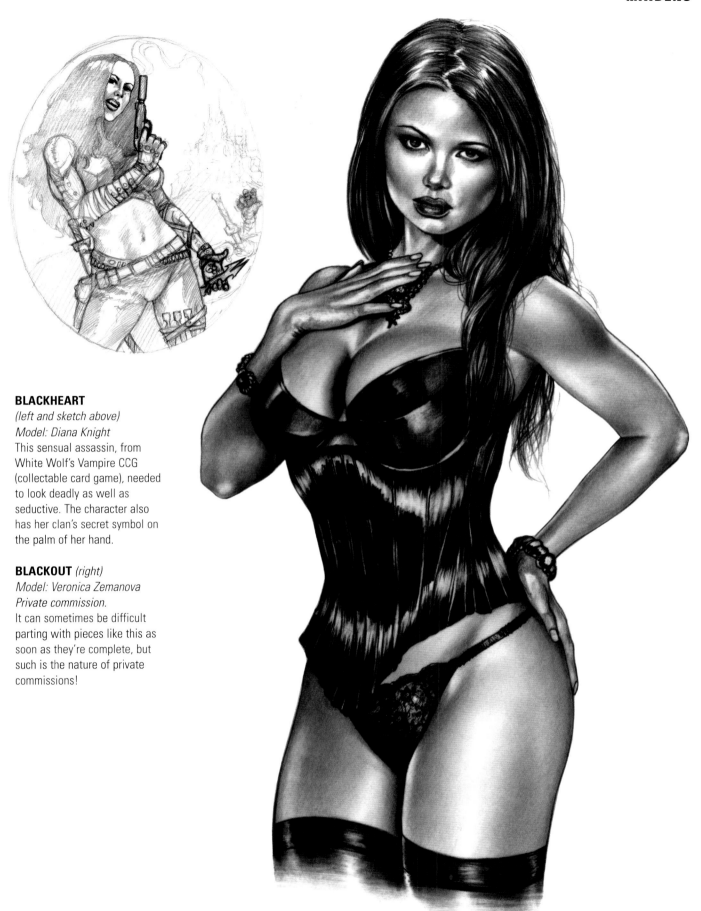

BLACKHEART
(left and sketch above)
Model: Diana Knight
This sensual assassin, from
White Wolf's Vampire CCG
(collectable card game), needed
to look deadly as well as
seductive. The character also
has her clan's secret symbol on
the palm of her hand.

BLACKOUT *(right)*
Model: Veronica Zemanova
Private commission.
It can sometimes be difficult
parting with pieces like this as
soon as they're complete, but
such is the nature of private
commissions!

• MONTE MICHAEL MOORE •

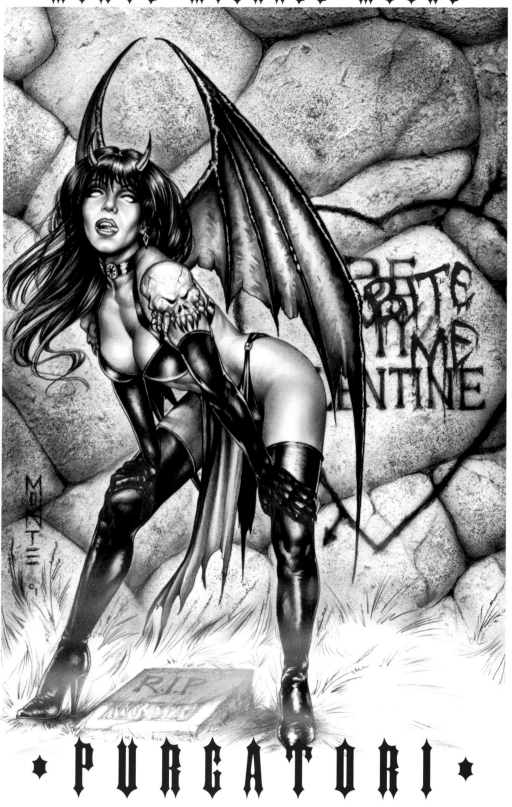

• PURGATORI •

BITE ME! *(left)*
Cover illustration for Chaos! Comics's Purgatori character. This is a very violent Valentine's Day vixen!

CAT TAILS *(right)*
Model: Sharon Bruneau
Sharon was the purr-fect choice for this catty commission, which was auctioned at the Pittsburgh Comic-Con's annual Make-A-Wish Foundation auction. I've drawn and painted Sharon several times. I guess I enjoy drawing powerful people!

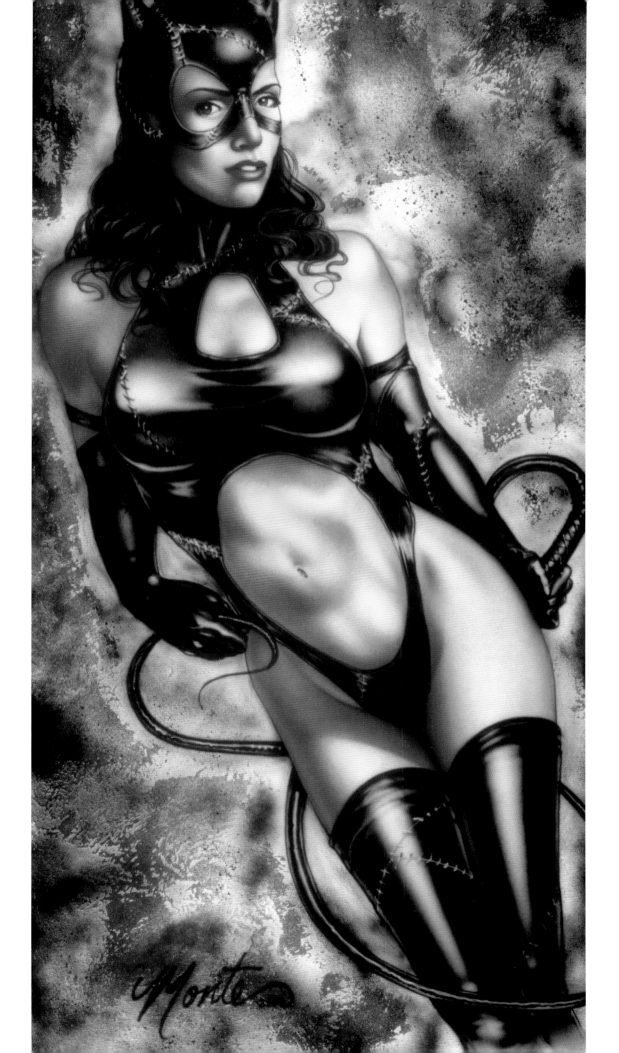

23

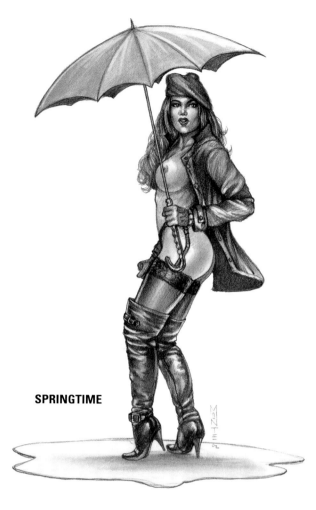

SPRINGTIME

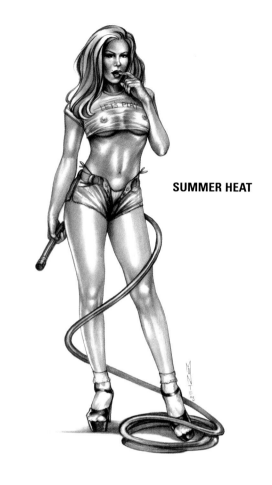

SUMMER HEAT

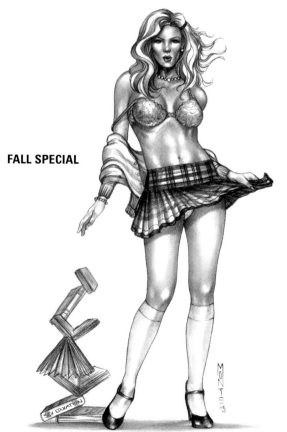

FALL SPECIAL

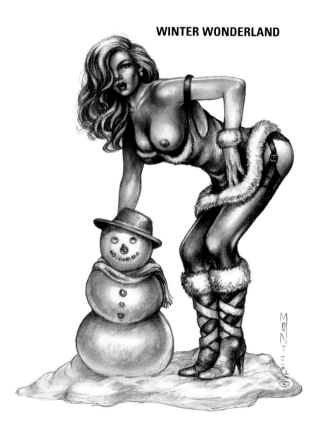

WINTER WONDERLAND

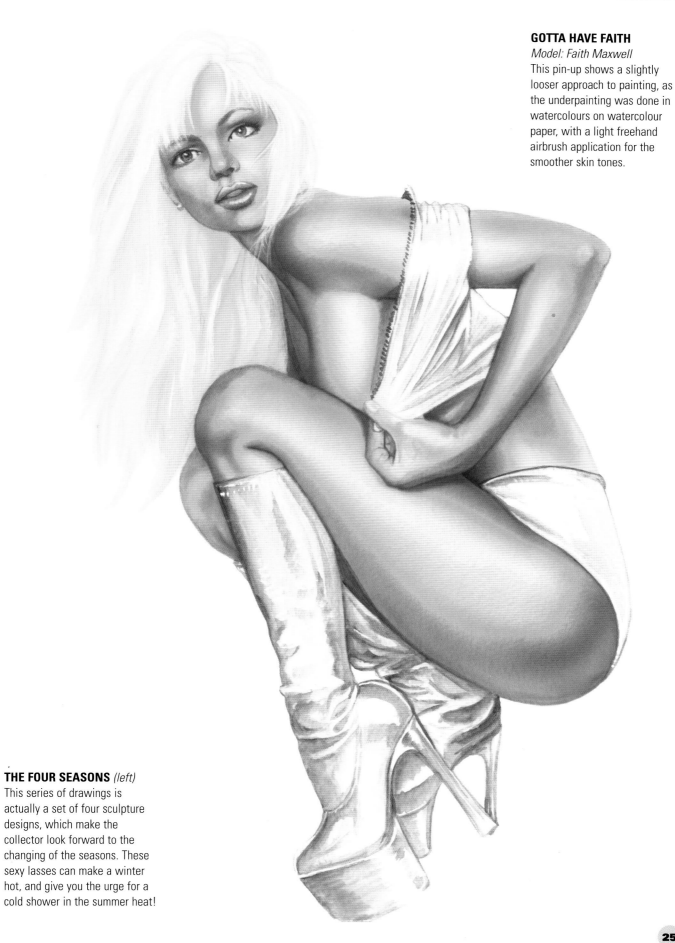

GOTTA HAVE FAITH
Model: Faith Maxwell
This pin-up shows a slightly looser approach to painting, as the underpainting was done in watercolours on watercolour paper, with a light freehand airbrush application for the smoother skin tones.

THE FOUR SEASONS *(left)*
This series of drawings is actually a set of four sculpture designs, which make the collector look forward to the changing of the seasons. These sexy lasses can make a winter hot, and give you the urge for a cold shower in the summer heat!

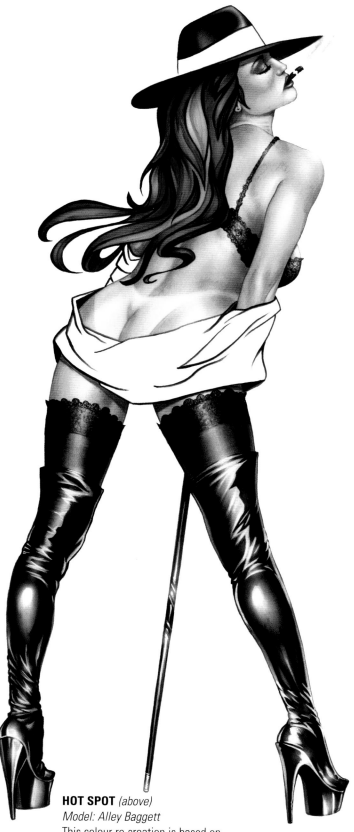

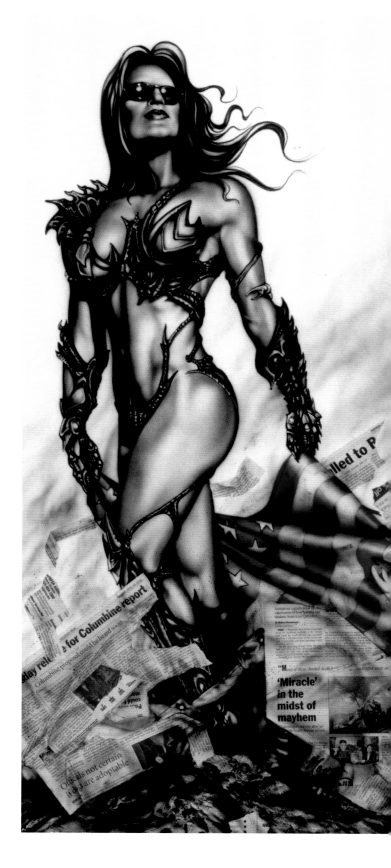

HOT SPOT (above)
Model: Alley Baggett
This colour re-creation is based on
an early 1990s drawing of mine
called Smokin'.

MIRACLE WORKER *(left)*
Model: Bonny Hendry
Collage is a technique I don't often employ, but I wanted the look of real blowing newspapers. This concept was later turned into my Standing United sculpture.

MAXED OUT *(right)*
Pencil illustration of a modified V-max motorcycle, done for Python Motor Sports. People have told me there's a bike in here somewhere!

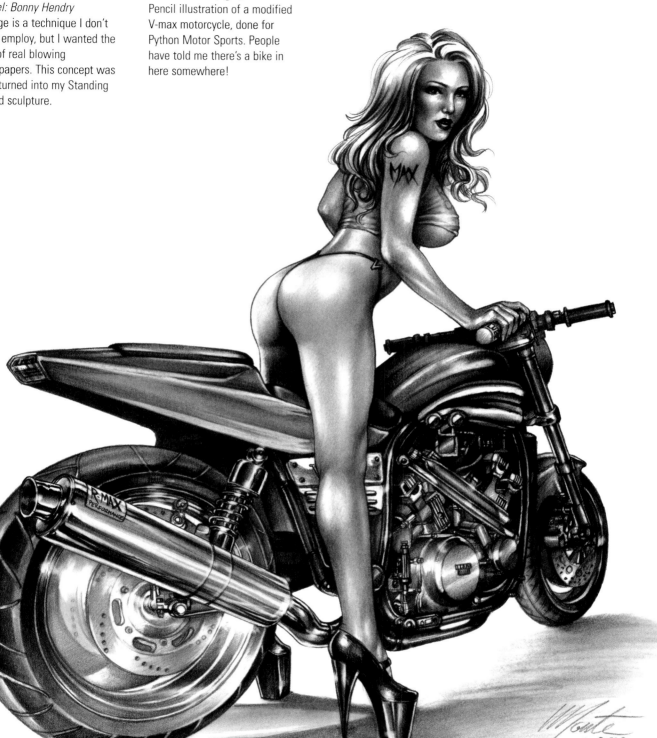

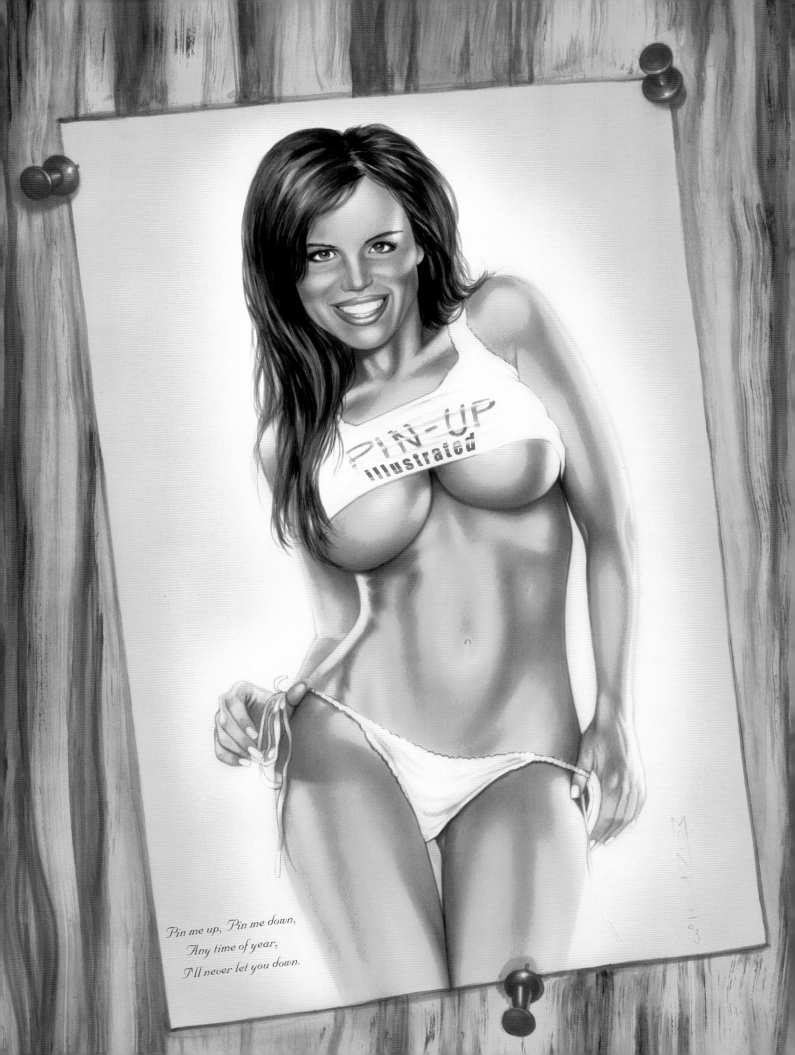

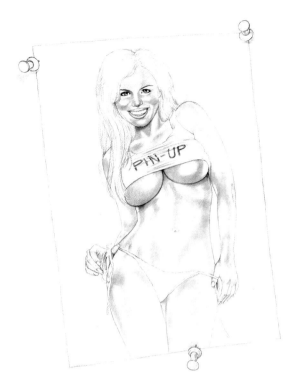

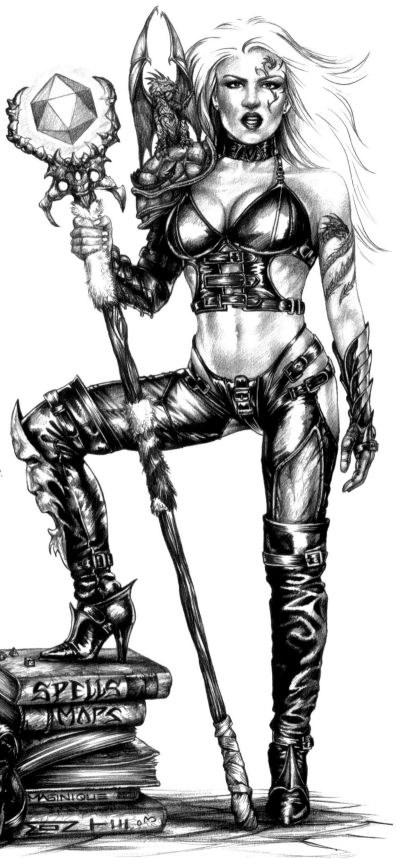

PIN-UP *(left and above)*
Model: Erin Ellington
These two images were done for the cover art of an issue of the magazine *Pin-Up Illustrated* that featured my artwork and an interview. I wanted this piece to be something of an homage to the great pin-up artists of the 1940s and 1950s, which is why I included the push-pins for effect and a small poem, much like many of the Esquire pin-ups of old.

SHE'S GOT GAME
Model: Manon Kelly
I did this drawing for a fantasy RPG (role-playing game) gamer T-shirt design called Wanna Play. For most of my drawings, I use only an HB lead pencil. For the second stage I apply graphite before using any smoothing techniques with tissue or blending stumps.

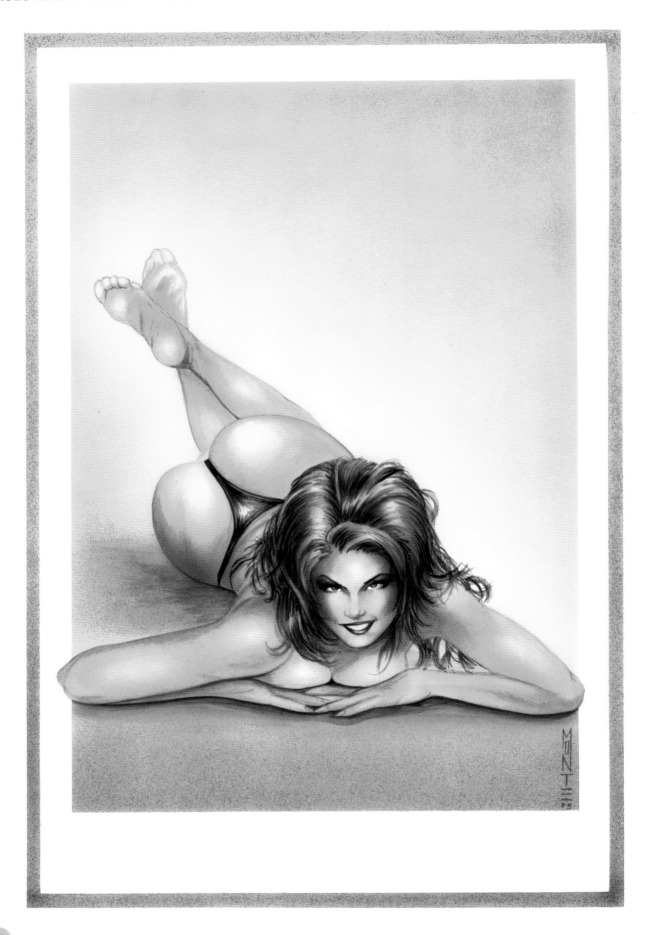

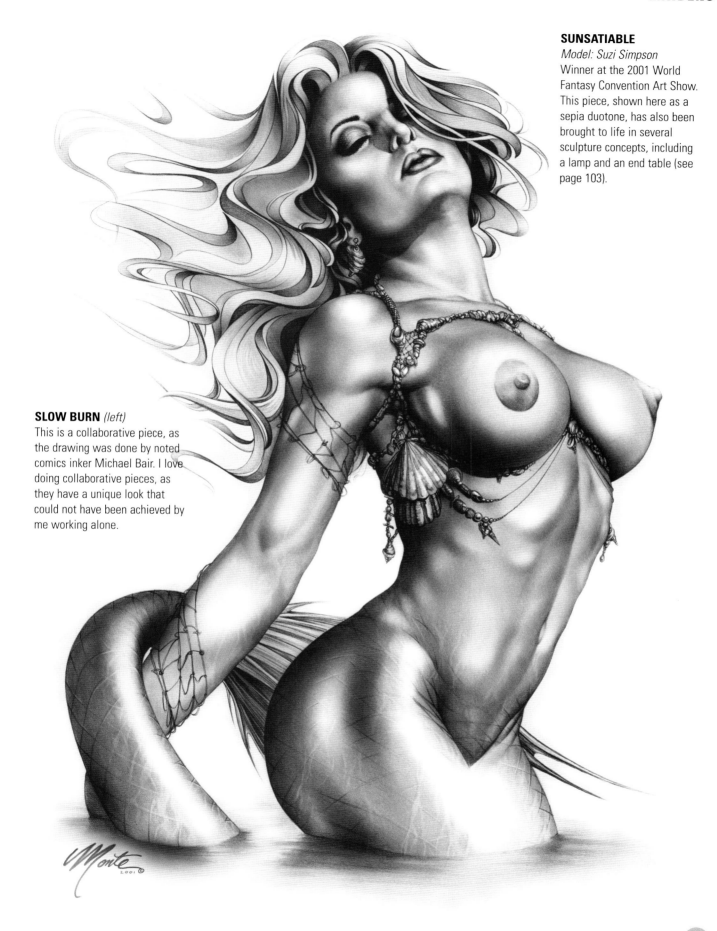

SUNSATIABLE
Model: Suzi Simpson
Winner at the 2001 World Fantasy Convention Art Show. This piece, shown here as a sepia duotone, has also been brought to life in several sculpture concepts, including a lamp and an end table (see page 103).

SLOW BURN *(left)*
This is a collaborative piece, as the drawing was done by noted comics inker Michael Bair. I love doing collaborative pieces, as they have a unique look that could not have been achieved by me working alone.

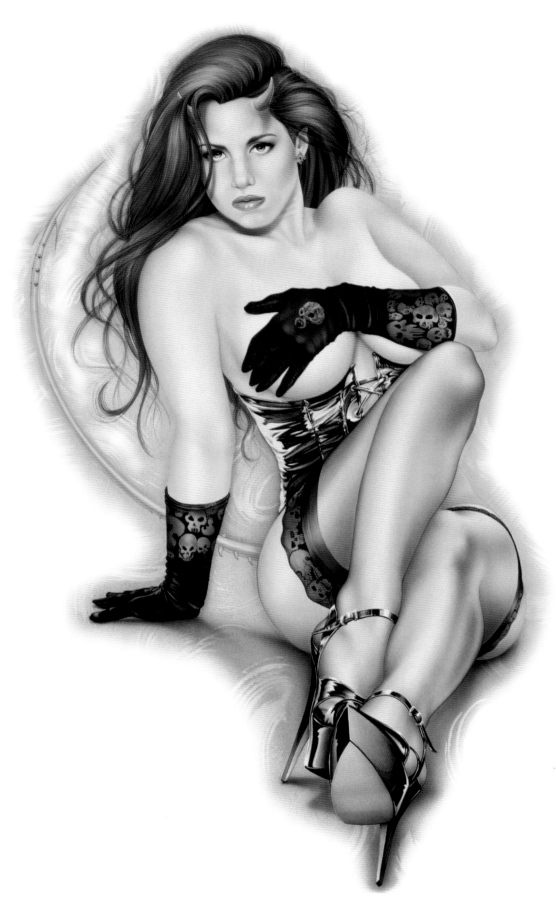

TEMPEST *(left)*
Acrylics on clayboard.
Clayboard (the brand name is actually Claybord) is a masonite board with a layer of compressed clay as its working surface. This is ideal for airbrush applications, as well as for eraser and X-Acto knife etching techniques.

SUZI *(right)*
Model: Suzi Simpson
This was the concept idea I submitted (successfully) to *Playboy* for their Uniquely Playmates limited-edition print project. When so much is on the line with a client like this, it pays to keep your concept art very tight.

PAGE 34
TREASURE HUNT
Model: Diana Knight
I think the title says it all really . . . since X really does mark the spot! This art gives new meaning to the term MapQuest.

PAGE 35
TURBO LOVER
Model: Zdenka Podkapova
A complete 'how to' based on this piece can be found at the back of my Mystica sketchbook. This is the third piece in my cyberider series Curve Machines.

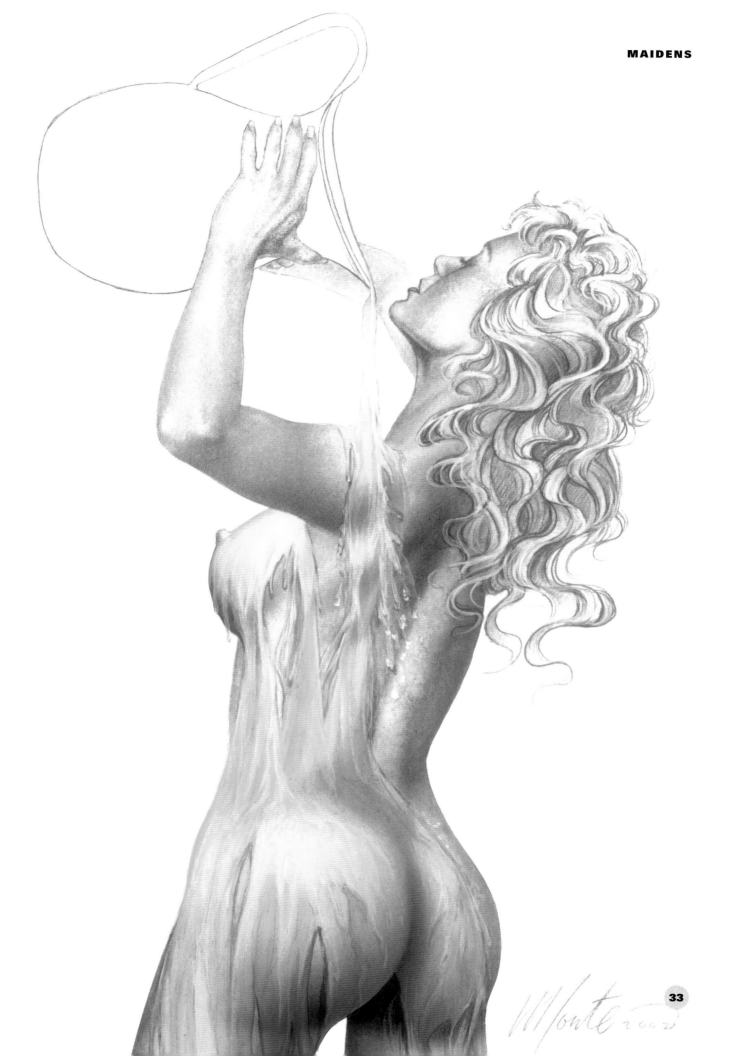

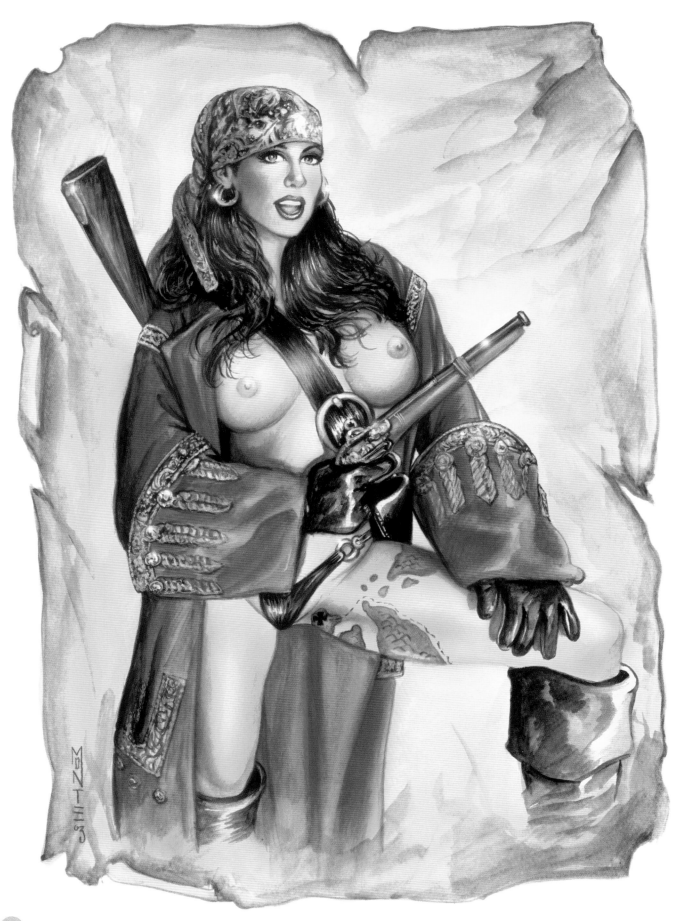

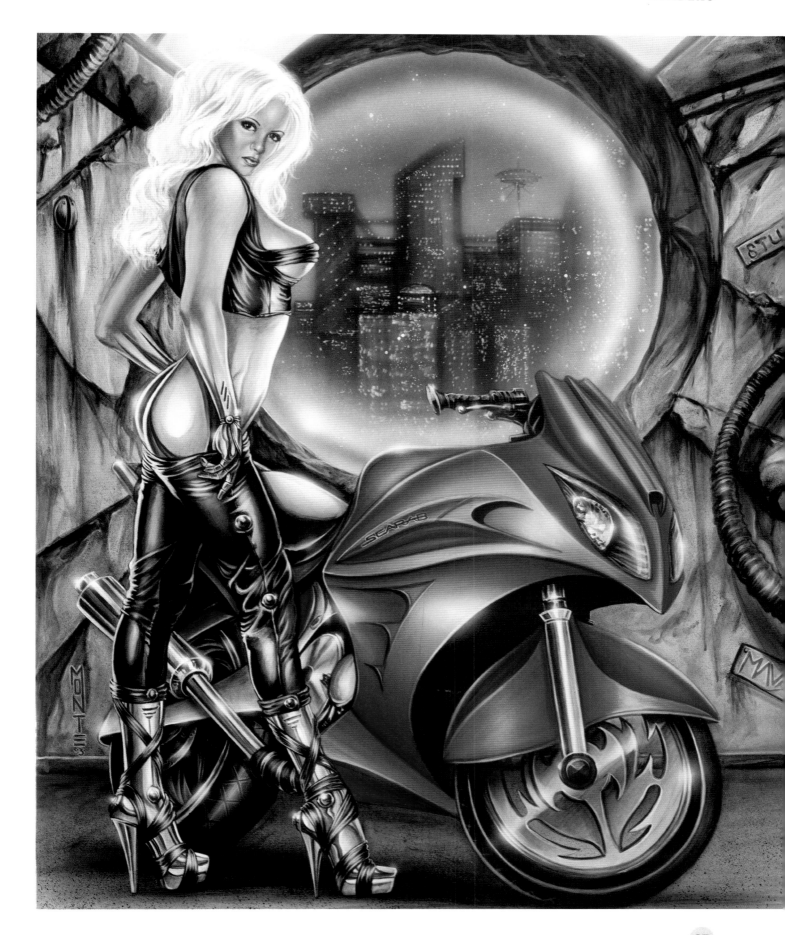

VAMP SKETCH
Concept sketch for the punk band The Misfits.

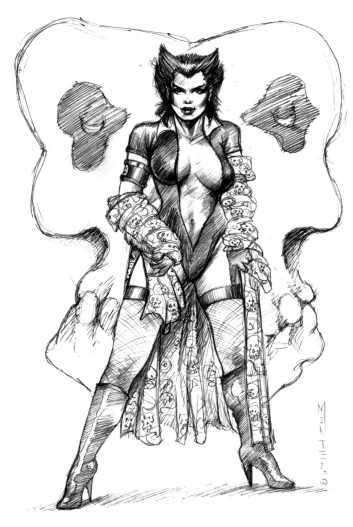

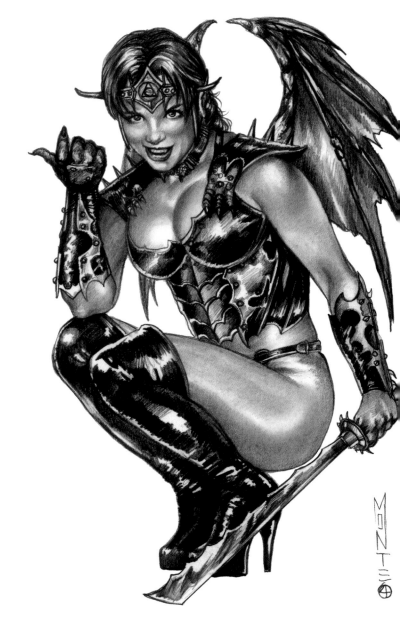

VIXENATION (above)
Model: Vera Vanguard
This 2004 drawing is really quite vixenly, and would also make an interesting sculpture design. Of course, any beautiful female with wings, leather, spikes and a blade makes for tasty subject matter.

SOJOURN (right)
CrossGen Comics character painted for a Make-A-Wish Foundation charity auction.

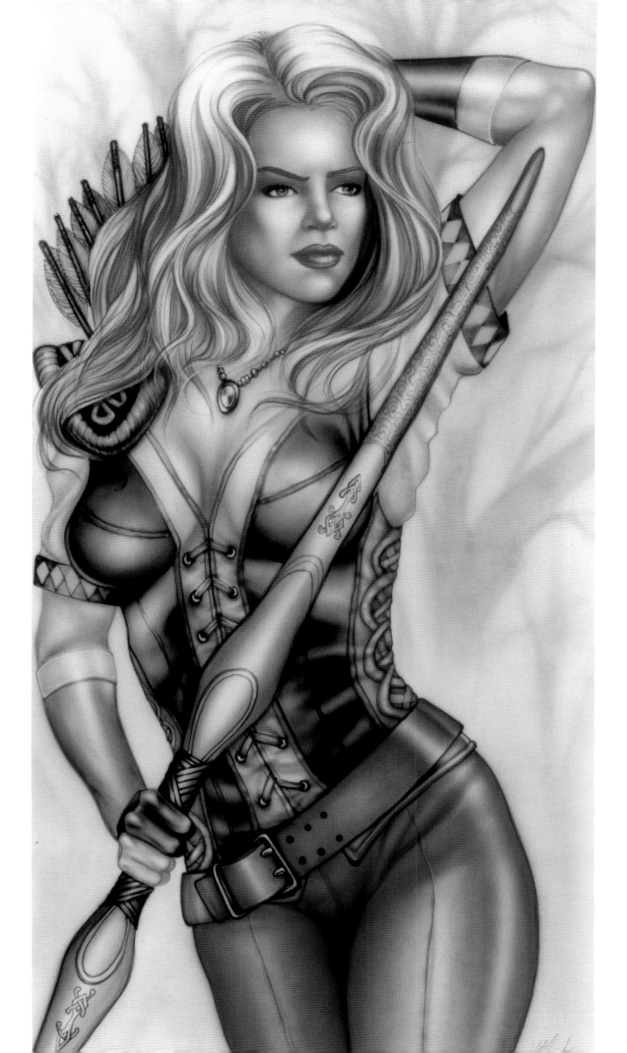

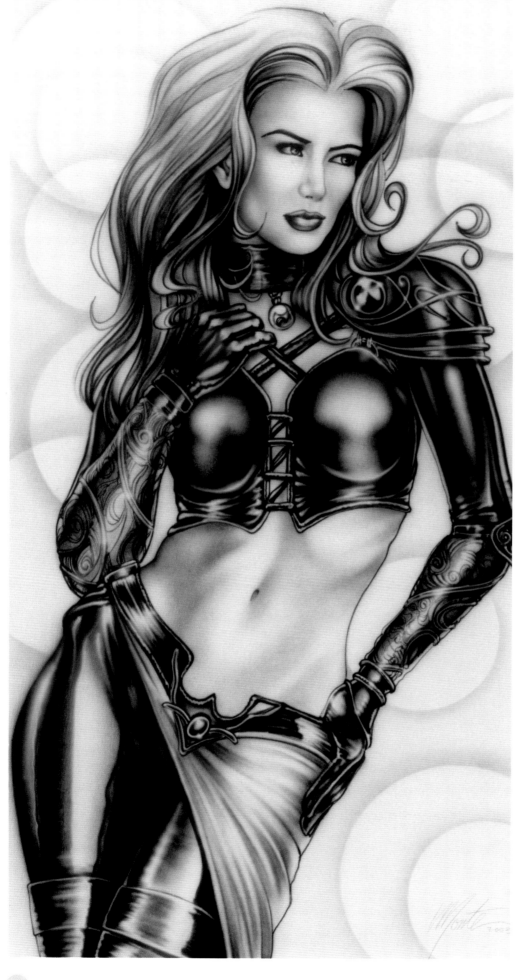

SCION *(left)*
Many of my larger canvas paintings are three feet by four feet in size, and typically they're done as just freehand airbrushed acrylics.

MAGINIQUE *(right)*
Model: Aria Giovanni
Cover illustration for my third art book, entitled *Maginique – Magic, Imagination and Technique*. The border was inspired by the ornate shapes of Art Nouveau-style backgrounds.

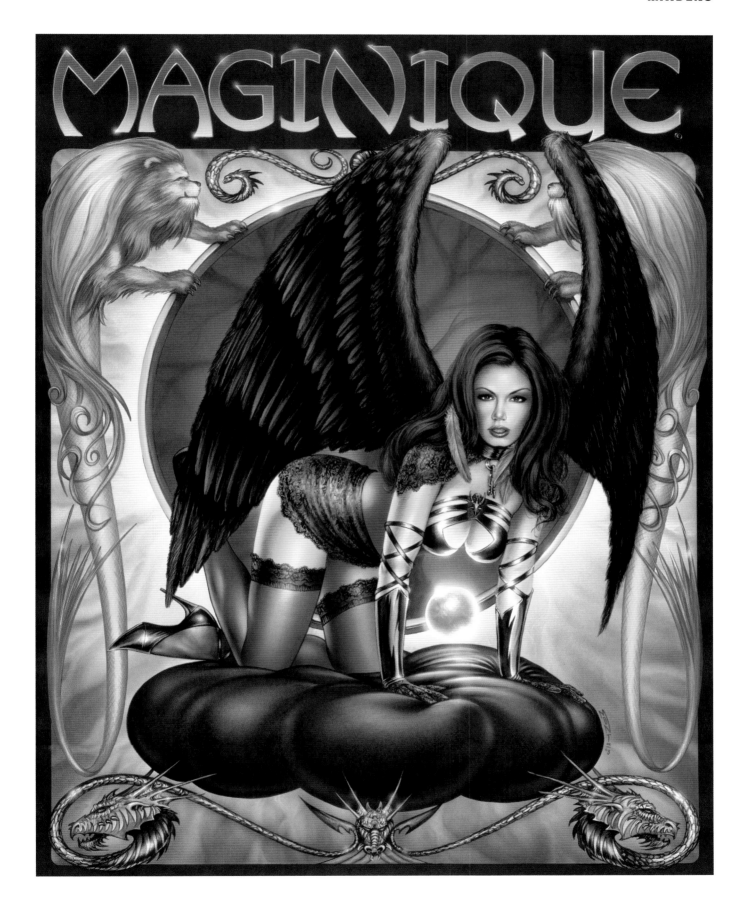

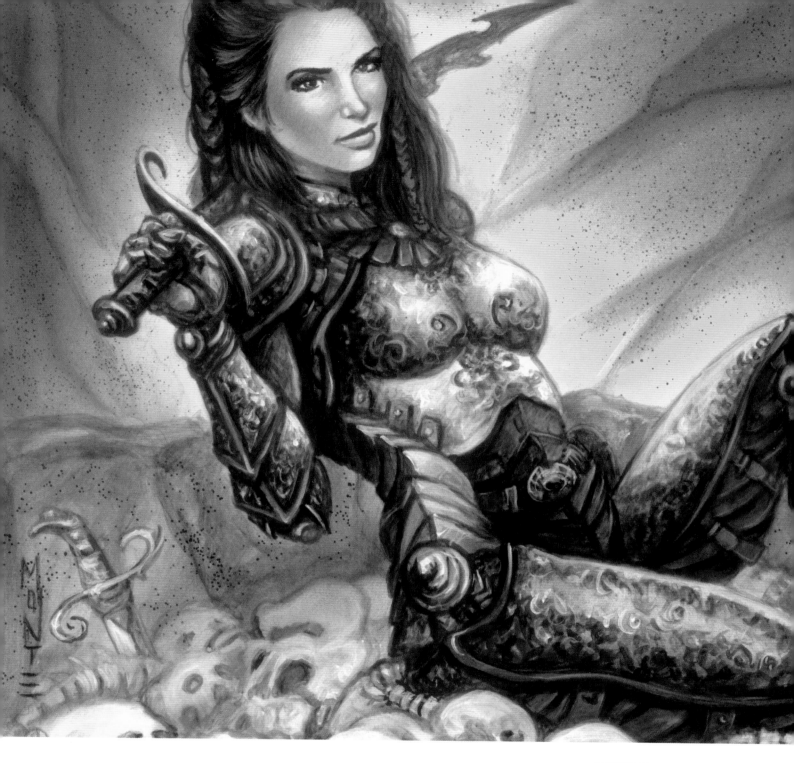

IRON MAIDEN *(above)*
This Warlord CCG illustration features an iron-clad female Paladin. This is the medieval version of lingerie, it just takes a lot longer to get undressed!

NAUGHTY PINE *(right)*
Model: Erin Ellington
This showcases my first piece of art featuring pyrography (wood-burning). I did this on pine wood, burning the details into the surface. I created the tones using airbrushed acrylics, and scratched out the flesh highlights with a knife. The background tone was stained with varnish for added effect.

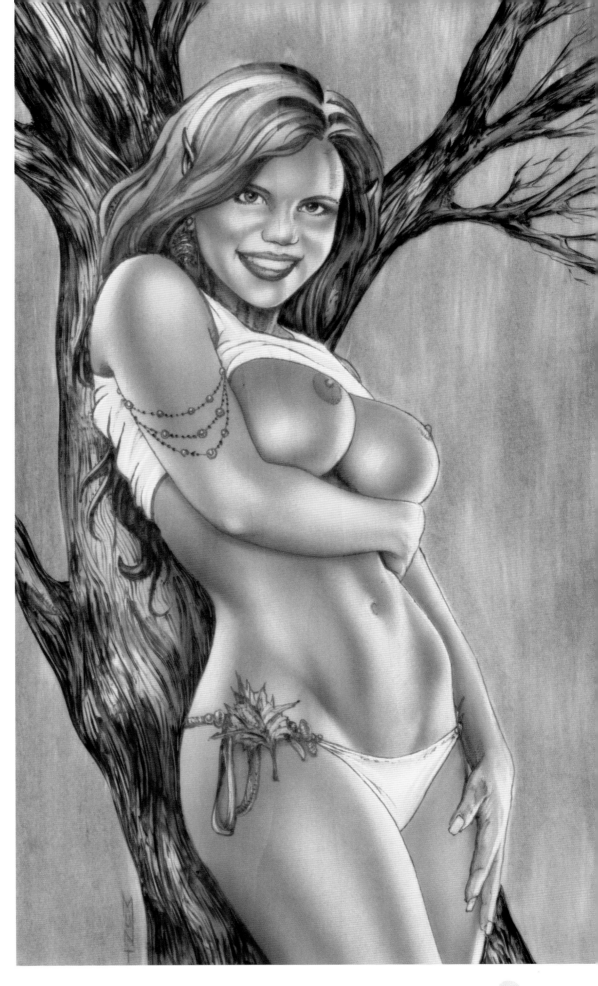

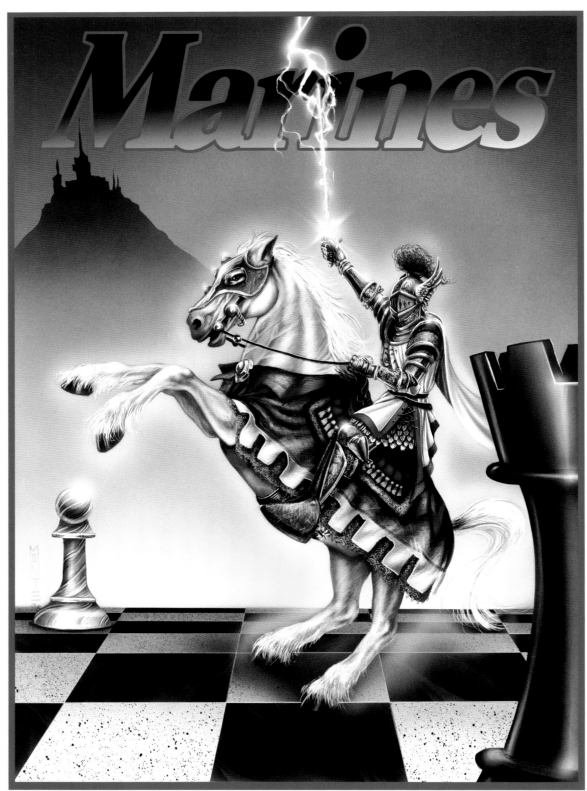

The Few. The Proud.

MARKETING

MARINE CORPS *(left)*
Illustration for US Marine Corps recruitment T-shirt, designed to be used with their national advertising campaign.

HARRY POTTER CARD *(right)*
Having an adaptive style is highly useful for an illustrator, such as in this Harry Potter CCG card. The style uses a simpler and brighter paint application than is customary for me.

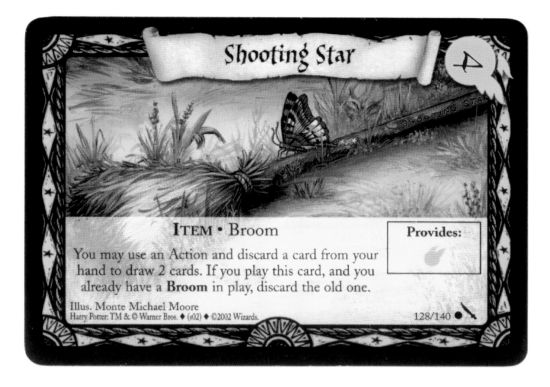

Blazing a trail for success

Maverick Marketing is the name of my company; the family business is called Maverick Ranch. The name arose because a maverick is 'someone who blazes a path or a trail for others to follow'. I have certainly done a lot of traditional marketing of my work to the public, but often the ideas for marketing and for the products I derive from my artwork just come to me naturally. Many people think I have a natural gift for marketing, but quite honestly I owe that marketing savvy to a lot of commercial success; the savvy in turns creates more commercial success, and so on. This doesn't mean I'm a better artist than a lot of the artists out there, but that I find ways to make my artwork more successful and available to the general public. It is also a perceived success, because the marketing efforts often compound themselves, with each achievement building towards the next one.

I have often said to young artists that you might be the best artist in the world but, if nobody knows of your creative vision, your genius is wasted: your artwork isn't being seen by the public. It's the same as when you see a bad movie and wonder how it ever got produced: what's happened is that somebody out there was better at marketing their ideas than all the people who had really great ideas that will never be turned into movies.

With this in mind, it is my belief that, to be a successful artist in today's world, your own marketing abilities or the people you get to market your artwork for you, are almost as important as the quality of the work itself. This comment applies mainly to the commercial art field, in which I have more experience, and may not necessarily pertain to the fine art field.

I don't do a lot of gallery work myself. I'm not personally a big fan of galleries since they can often take 40–60 percent of the proceeds from the sale of a painting when all they're doing is providing a space to hang it and a certain amount of marketing.

When I was getting started in marketing, I had to borrow the money for the very first print run of my Sunkissed mermaid print. I didn't know much about the industry and I didn't have a distributor, but I knew this was something I wanted to do. Selling prints of your artwork is a very successful way to make sure people can obtain your artwork without having to find the cost of an original, which anyway they may not have a particular desire to own.

A grass roots approach

One of reasons why people have told me that I must have a natural gift for marketing is that I never had any marketing classes in college. In ten years of going to conventions I have gone from being a lone artist at one table with one chair and one print on display to having a much grander presentation, with back walls, lighting, sketchbooks, sculptures and a variety of products for sale. Not only is this how I make my living, I want to make my artwork available to the public. Even if it's just a matter of a child wanting to buy something as simple as a signed Harry Potter card, you shouldn't be so inaccessible that you don't have time for the people who have helped make your career successful. Besides, that child may grow up very swiftly indeed to become an art director or a significant collector. People are amazed that they can walk right up to me at a show and have a ten- or fifteen-minute conversation with me, or that when they call me at the office to order a sculpture I'm the guy who picks up the phone. Of course, some days I might be too busy for that, but I take great pride in my personal approach: I'm the same guy as the artist. I'm just lucky enough to be someone who's able to create art for a living.

That doesn't mean it hasn't been a very long road, or that there hasn't been a lot of hard work involved. But as long as I can I want to continue making that personal effort to market my artwork and correspond with potential clients. If I'm readily accessible the relationship becomes more like a friendship than simply a commercial transaction.

In terms of Maverick Marketing, I take a kind of a guerrilla marketing approach. I guess my view has always been that you don't have to spend a lot of money to market your artwork successfully. At the very beginning of my career I was talked into placing an ad in one of the large illustrator source books; even though my work was as good as or better than much of the rest in there, in retrospect I feel I wasn't ready or able to compete on a national level. I didn't gain many jobs from that ad. Instead I've adopted a longer-term grass roots approach, attending a lot of conventions, mailing samples and packets of artwork to art directors, and doing follow-up phone calls (not a pleasant part of the job). This means that, unfortunately, I spend almost more of the time I'm in the office doing business than on creating my artwork, which I often have to do in my home studio after hours. But, if you don't make those follow-up phone calls, mail those samples and check that the correct art director is getting them, your potential clients more than likely aren't going to know you exist.

SUNKISSED *(right)*
The very first Monte Moore limited-edition print, and the beginning of my career as a pin-up artist.

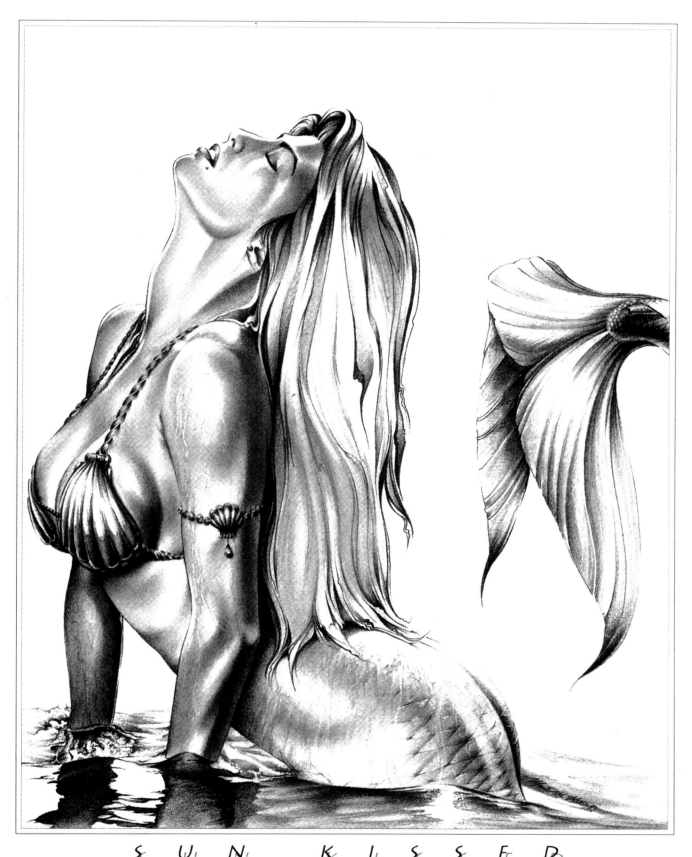

SUN KISSED

MONTE MICHAEL MOORE

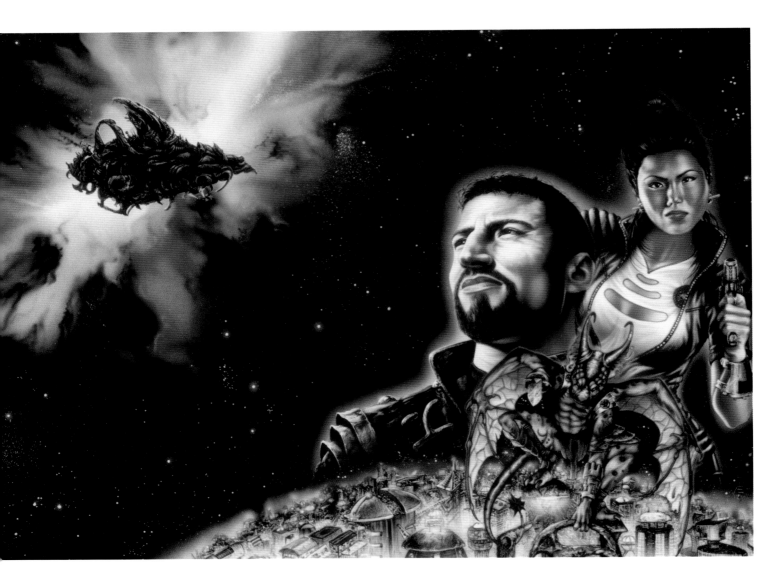

ZERO POINT
Cover for a TSR novel – not only my first novel cover but also my first assignment for Wizards of the Coast. This represented the first big break of my career so far as the fantasy and sf fields were concerned.

Strategies for success

My first big break in getting work from Wizards of the Coast came through a follow-up call I made to an art director who proved not to have received my art samples. He was out when I called but – rarely for an art director – returned my call and made sure he got my samples. Within four or five days I'd landed the largest project of my career!

The key when submitting samples is to have the name and address of the art director – not just the name of the company. This is an absolute must. When submitting to a large book publisher you need to mail your samples directly, by name, to the person who should be looking at them, not just to a department or job title; otherwise your work is going to be put in a very large slush pile and is likely never to be seen. When you meet someone at a convention, get their business card, then follow up with them personally.

I'm also a big advocate of using the internet to market your artwork. A large majority of my projects and clients come from people seeing my artwork on my own web site (http://www.mavarts.com), on a fan web site, or on a paid-for illustrator site such as portfolios.com. Having your own web site is of paramount importance, another absolute must.

It's an online gallery exhibiting your artwork 24 hours a day. On your site you can say whatever you want about your philosophy, prices and clients. I can't tell you how valuable it is. I don't think you should rush out and get a web site until you're ready for it, but once you are you'll find they're generally inexpensive.

The second strand of an internet marketing strategy concerns e-mail. I don't do just mass e-mails to potential clients but instead tailor my e-mails to each individual client. Often you can find the art director's name and e-mail address on the company web site, or you can send an e-mail to the general company e-address asking for the art director's own one.

Generally what I do when e-mailing is attach a very brief letter of introduction that tells about myself, my clients, accolades I've received and my experience. I also attach a few images – low-resolution images that open very quickly. Art directors won't bother opening large, high-resolution files; they don't need to see every hair on the subject's head. All they want is a quick overview and a link to your web site with a request that they visit it if they feel your work might be appropriate.

I find this approach the most effective for me. I often keep a copy of my original e-mail so I can follow-up in 4–6 months if I haven't heard back from that art director.

Keeping ahead of the competition

At times, getting a dream client can require a sustained campaign – it might take even as long as a few years to nail them down – and there's a fine line between being persistent and being a pain. However, you do want to show you genuinely desire to work for them. Art directors like the fact that you don't adopt a take-it-or-leave-it approach. I find that having a positive attitude – 'Hey, I want to work for you because I like the quality your company produces' – gets you much further than 'Hey, I'm good, so of course you should hire me.' Because the world is full of quality artists, the ball's in the art directors' court. It's up to them to choose who they want to hire in an incredibly competitive field. If you don't believe me, you don't know the industry very well.

If a heart doctor and a foot doctor have offices right next to each other, they're really not going to compete that much for clients – indeed, the proximity might actually help them both. But at any convention you'll find there are fifty or a hundred accomplished artists of whom any one could be a good fit for a project. So it's up to you to make an art director or the owner of a publishing company believe that you are the person for a particular job because of a combination of your desire, skills, availability and price. All of those things need to come together so that you're not underselling your artwork but at the same time are assuring potential clients they'll be getting value for their money. It's a matter of stepping stones, really: you have to set your goals and achieve them, then raise the bar of the quality and quote prices for your artwork based on how much you want to work for the particular client. Remember that you are not in this industry just for the money, but that the term 'starving artist' didn't come from nowhere! The money can be there, but you've got to seek it.

Delivering the goods

All artists, no matter how successful their careers, have had their share of disappointments. Not every client you want to work for will come banging at your door. I keep a stack of rejection letters, and I've used them to light the fire of my desire to work for the people who've sent them! My outlook is that you should want to prove them wrong if they've said you're not ready; sometimes they might be right, but that doesn't mean you'll never reach the level they're looking for. Sometimes a specific style a magazine or publication wants might be forever unmatchable with the kind of artwork you do, but that's rare. Most of the companies who rejected my approaches earlier in my career, in some instances twice or three times, have eventually become clients of mine. Perseverance pays.

The larger the company, the more artists they have to choose from, which makes selling yourself to them that much more competitive. You need to do whatever it takes to make you the most marketable, the most attainable, the easiest-to-work-with artist, and you must let them know you're going to be able to hit their deadlines.

Lots of artists, especially in the comic-book industry, can't hit deadlines. They've never developed the work ethic and habits to keep to schedules because they haven't the diligence or discipline to get up every morning and work a full day as you would if you were in a nine-to-five job. They keep what I call Batman hours — working late at night. You often do have to do this as an illustrator, but your social and family life can suffer if you don't keep it to a minimum. A strict work ethic can help you meet your deadlines as long as you know what you can accomplish in a given time frame. The essential part is not to disappoint your clients by promising what you can't deliver. One missed deadline can mean you'll never get work from them again. This is why I've made a point of never missing a deadline in my career. My record assures art directors when they call me that I'll deliver the quality product they're paying me to create, and on time. If that means I have to stay up all night or work thirty-six hours straight, then so be it. My name is going to be on that project, and the quality has to speak for me. I won't just turn out second-rate work and say blithely, 'Too bad — that's all you can get in the time.'

Making it happen

To sum up my views:

If you're interested in getting started in today's market, work diligently to become the best artist you can be. Build a web site and use e-mail to your advantage (it's an inexpensive way to reach clients). Use the internet to find clients who want the kind of artwork you want to do. Attend conventions whenever possible (this can play a very large part in the realization of your dreams). Be as professional and friendly as possible — develop a mixture of personality and professionalism to ensure you can hit deadlines, offer fair prices, and are easy to work with.

One particular aspect of being easy to work with deserves special attention. When a client requests a change to your artwork, don't take it personally. Many artists don't achieve commercial success because they can't remove themselves enough from their artwork. Having an art director make a major change to their painting is taken as a personal attack, and they go

on the defensive – not a very smart approach to getting more work from that client.

I feel that, if you work long enough and hard enough without giving up your dreams, then you can achieve them. Whether you are already talented or still developing your skills, you can make it happen, but no one will do it for you. As Confucius says, 'A roast duck never flies into an open mouth.' You have to go get that duck, and it is up to you alone to do it. No one is going to hand success to you on a platter.

If you're prepared to take the time and effort to make a painting a success, it stands to reason that, if you use the same amount of energy to make your products available to the public, you will, hopefully, attain the same measure of success. There are no guarantees, but you won't know unless you do it. You really do have to maximize your efforts to make your work available to the public.

Creativity is comparable to light. A broad ray of sunshine can be very warm. But that same energy, focused into a tight laser beam, becomes something incredibly hot. When creativity is focused on producing artwork, amazing things can happen. Raw talent can make your art like sunshine, but learning skills can make your art a red-hot laser beam!

ART ATTACK!
Self-portrait.
Sometimes an artist fights to create art. Sometimes it fights back!

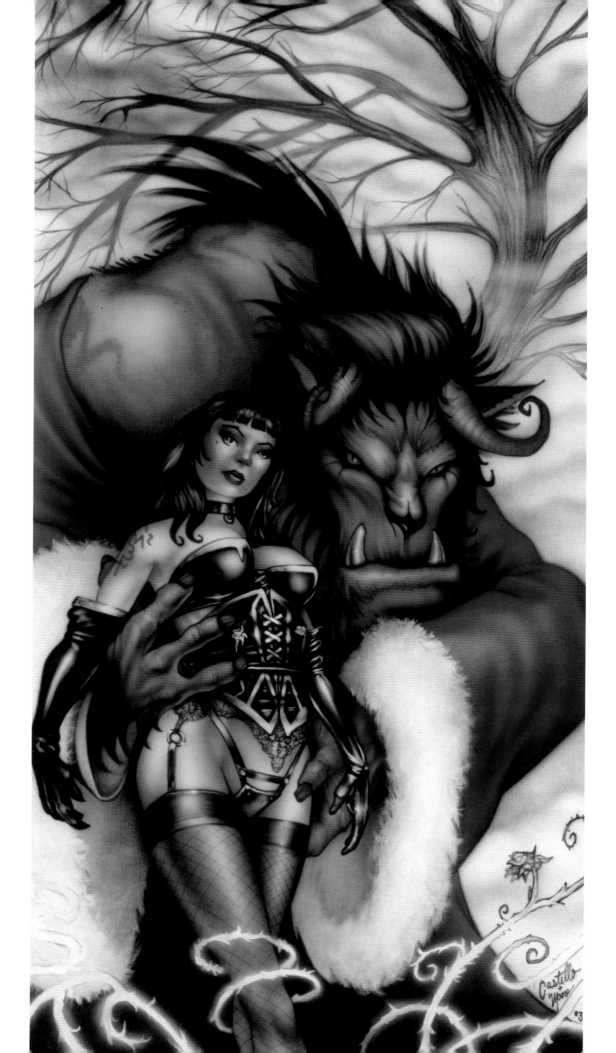

MONSTERS AND MAGIC

BETTY AND THE BEAST (left)
Freehand airbrush on canvas.
The original concept was drawn by my friend Tommy Castillo, well known for his creature features.

BONE DIGGER (right)
Concept sketch for the punk band The Misfits. Later I adapted it for a sculpture design.

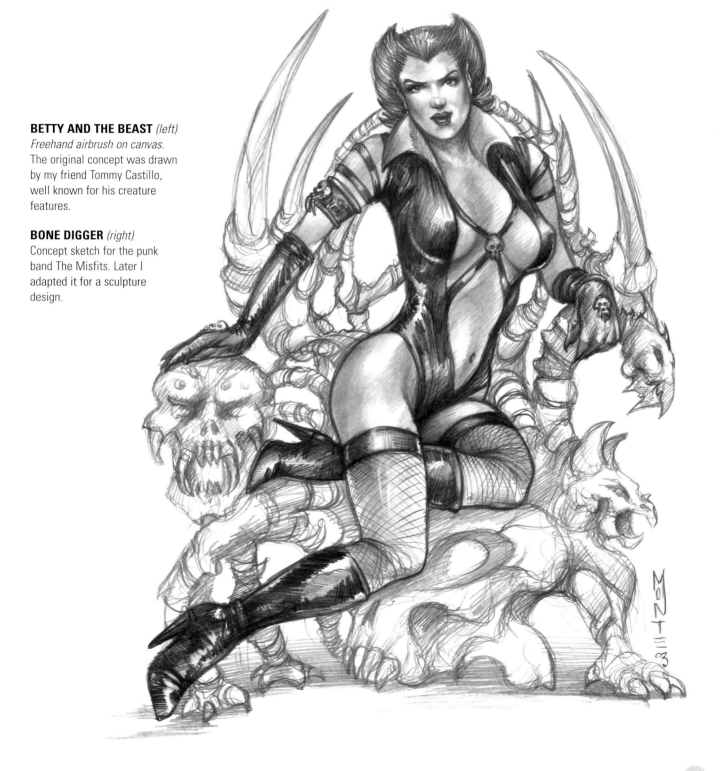

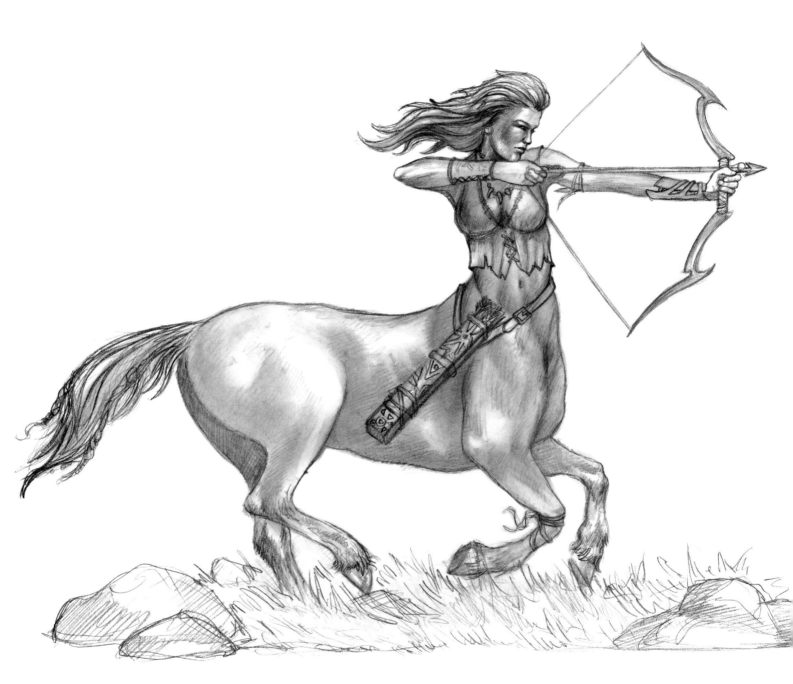

CENTAURIAN
Concept sketch for a Dungeons & Dragons female centaur.

LADY DEATH (right)
Done in 1998 as a calendar illustration for the now defunct Chaos! Comics, this painting of their character Lady Death was never published.

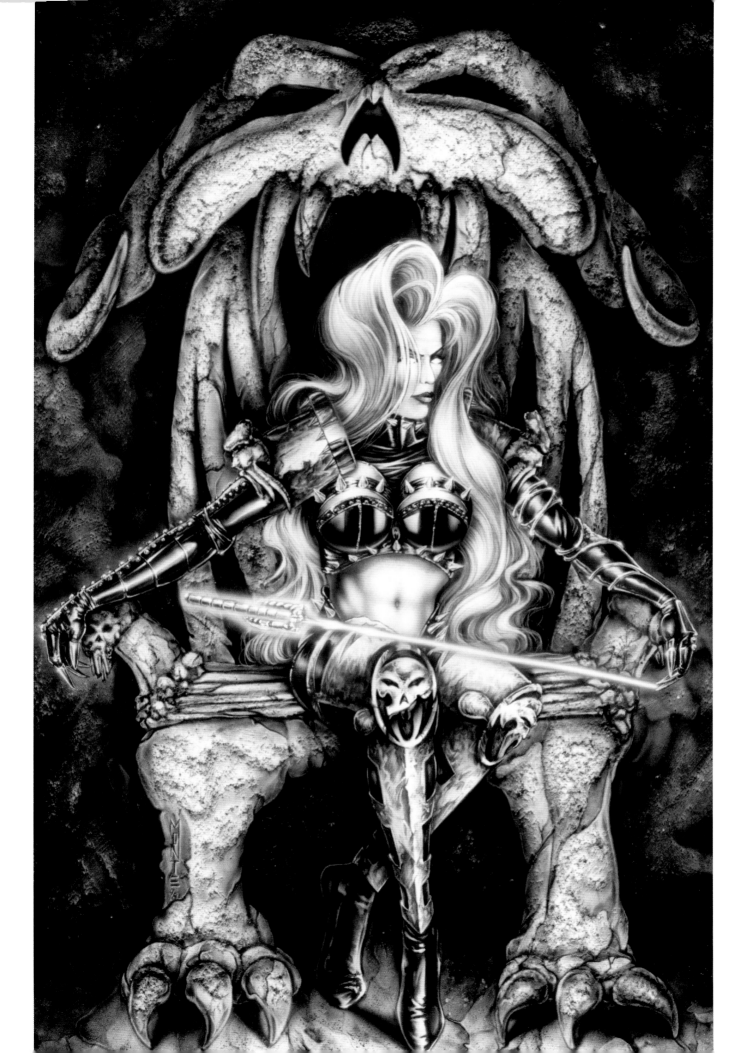

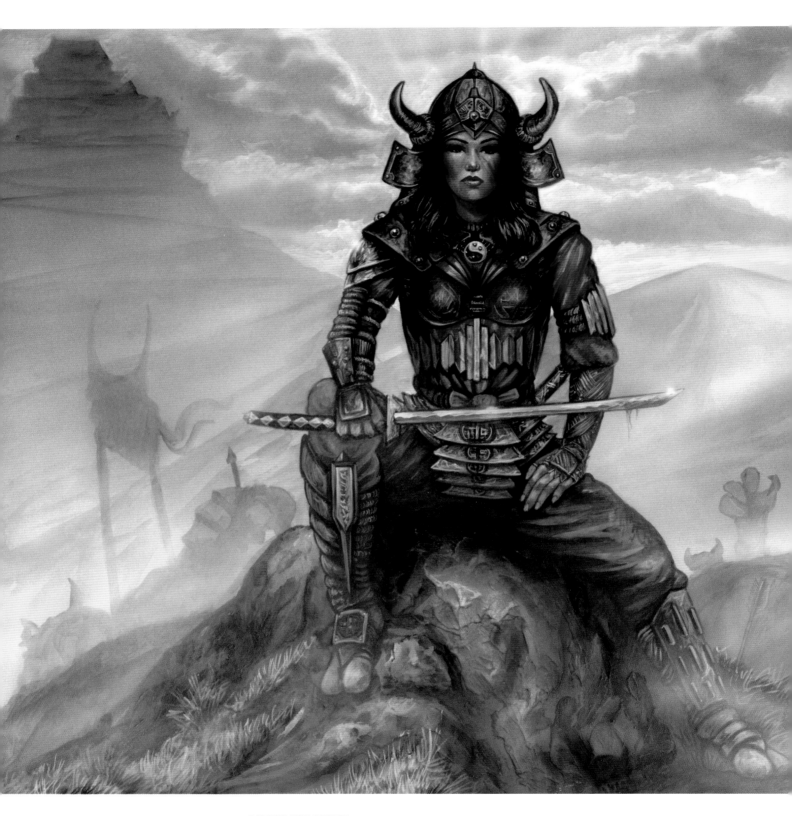

SAMURAI'S DAWN
CCG art for Alderac
Entertainment Group's Legend
of the Five Rings game.

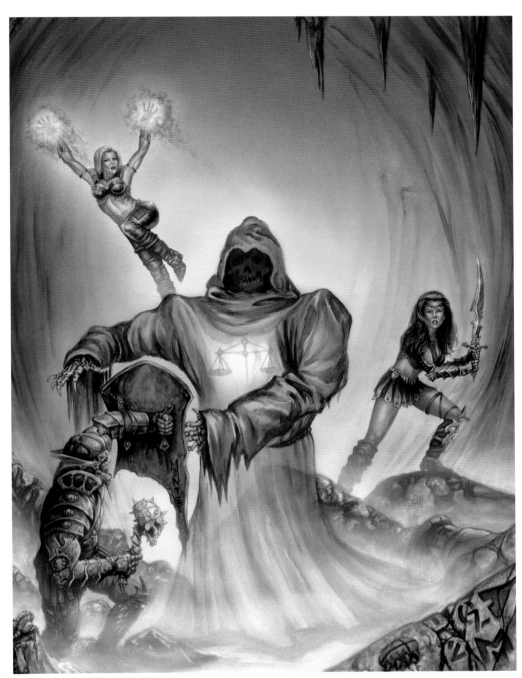

ON TRIAL

Fast Forward Entertainment module cover.

Illustrators often have to be quick and adaptive to meet their clients' needs. This cover was finished a day and a half after I'd received an urgent plea for help from the art director. It's always nice to be able to help somebody in a jam, and it usually means you'll get future assignments from them.

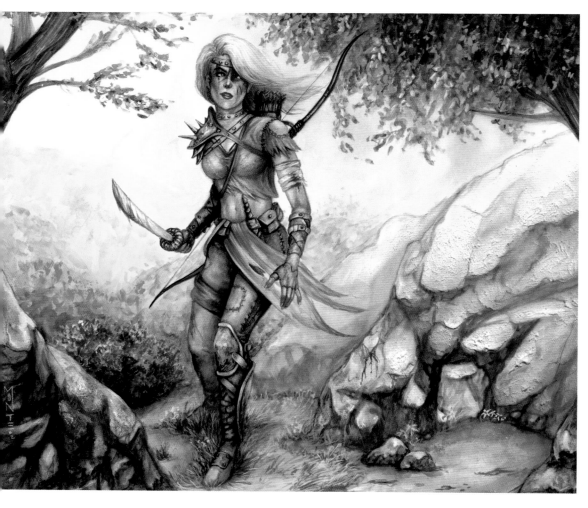

RANGER *(above)*
CCG card done for Alderac Entertainment Group's Warlord game. Most original card paintings are not very large – usually around 6 x 8 in or 8 x 10 in. Artists in this field have to get used to painting details very small.

RESURRECTION *(right)*
CCG illustration for Magic the Gathering. Even though not all the details in a small illustration may be seen in the printed product, I still include them so the original will be more appealing to art collectors.

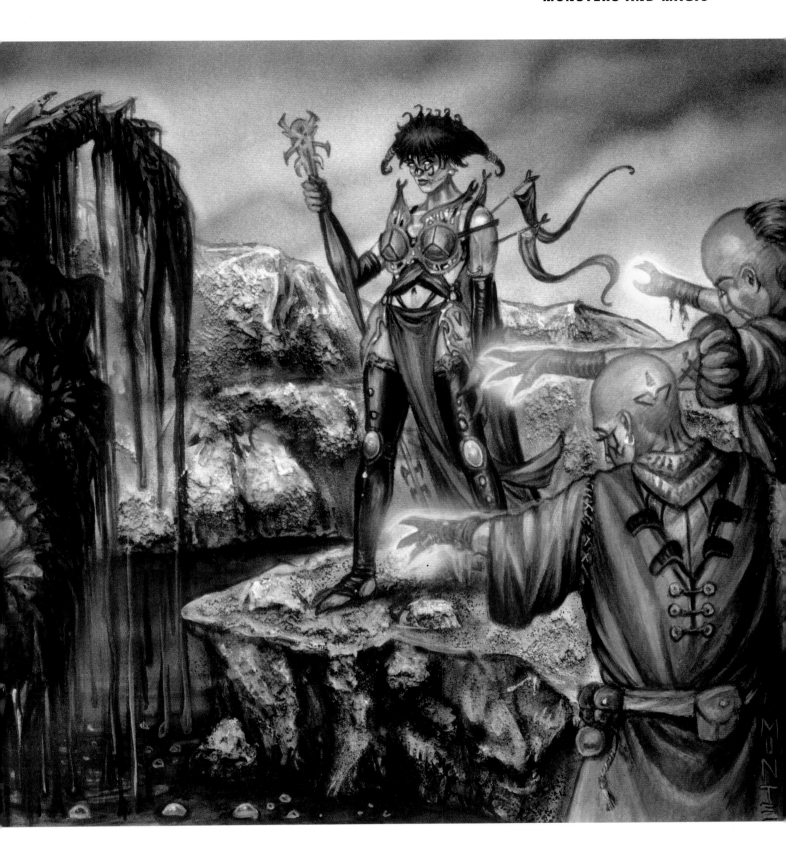

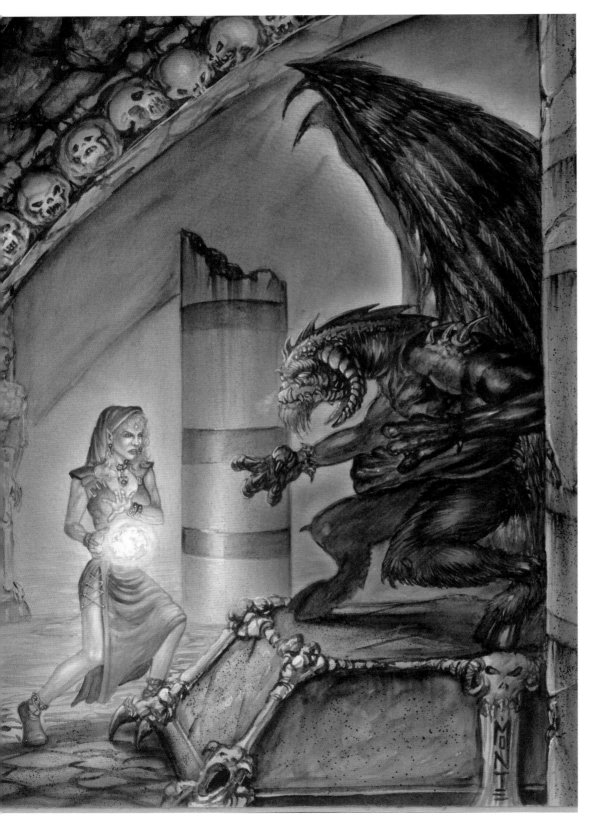

RACLOS WIZARDS *(left)*
RPG cover art done for the company Realms of Imagination. This piece is primarily watercolour and gouache, with just a little airbrushed acrylic for special effects. I think an artist should experiment with different media whenever possible.

ON DANGEROUS GROUND *(right)*
This Gamma World RPG cover was a favourite of mine. Too bad it was stolen at a show in Pittsburgh – please keep your eyes peeled in case you come across it!

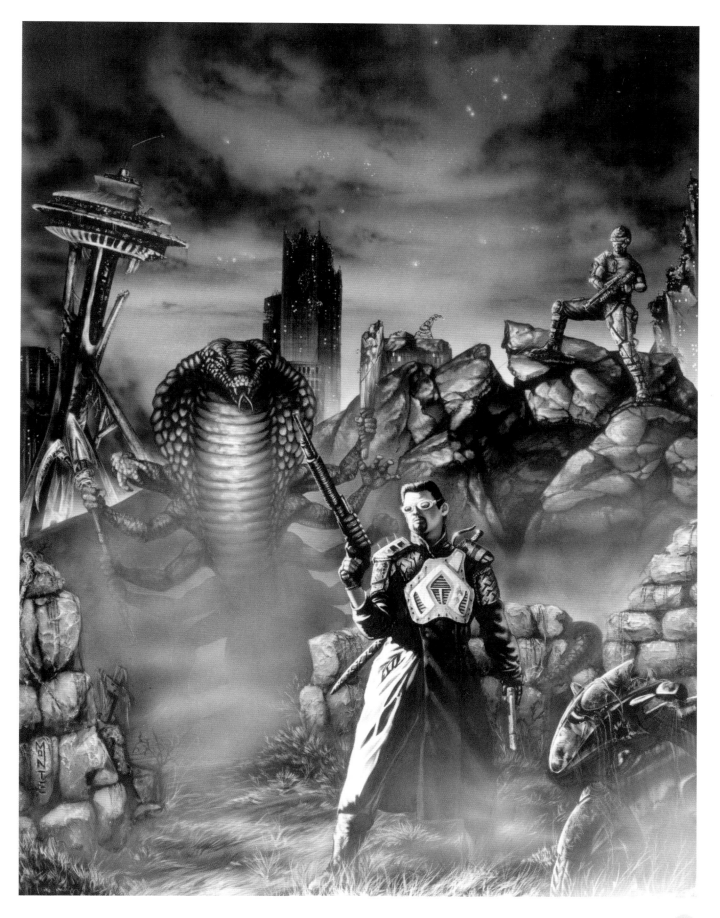

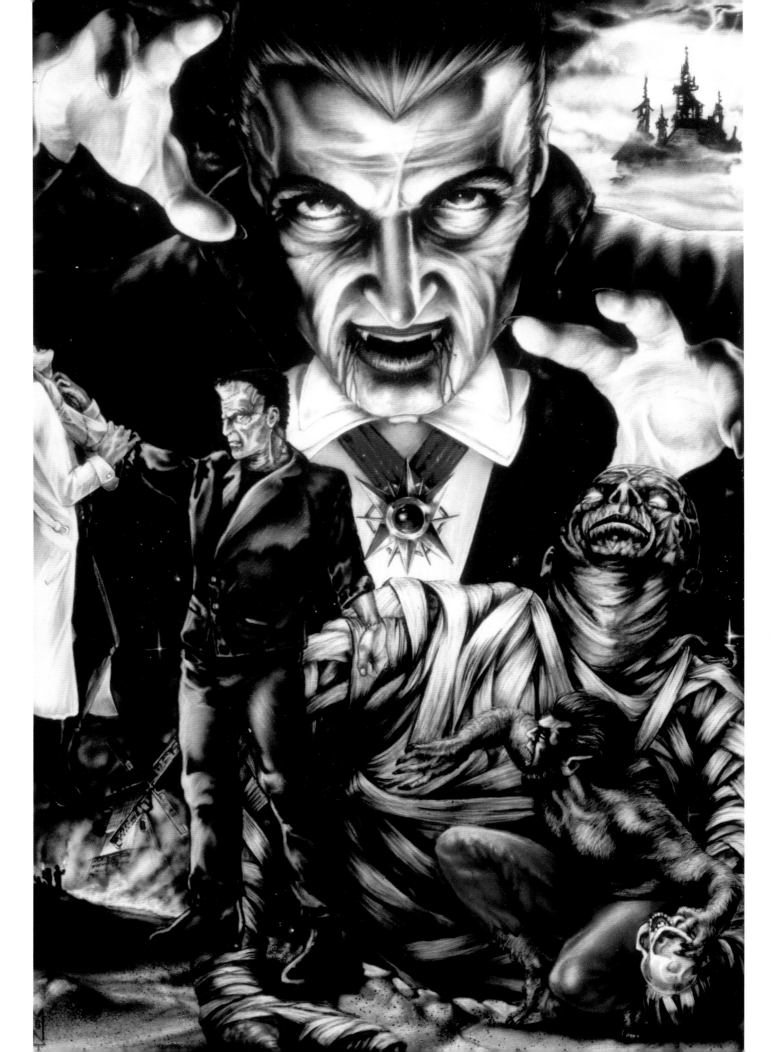

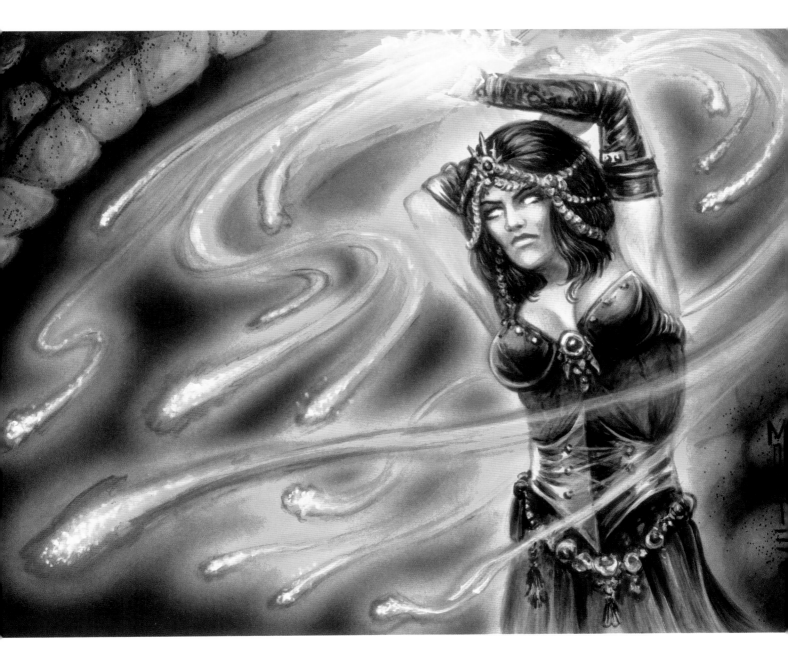

THINGS THAT GO BUMP IN THE NIGHT (left)
Another stolen painting. This original montage features Universal's prized scaremeisters.

DANCING LIGHTS (above)
Warlord card for AEG's popular CCG game.
Art for these styles of games are mostly derived from small written descriptions, and it's up to the artist to come up with a lively artistic solution to make the cards visually dynamic.

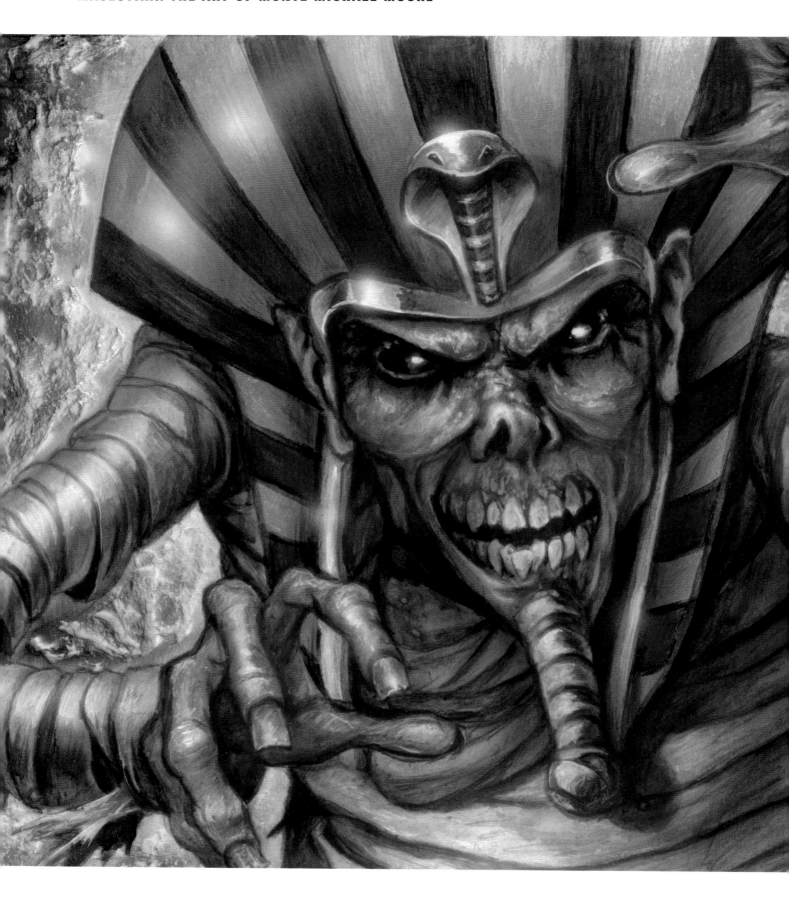

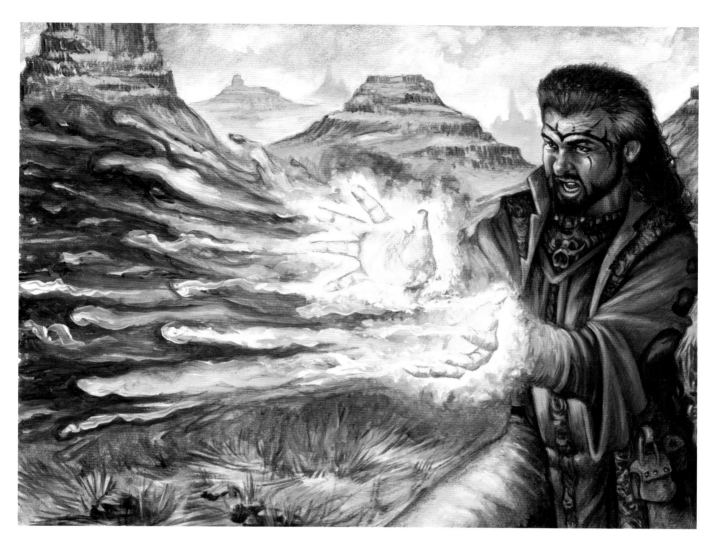

LAVAMANCER *(above)*
This Magic the Gathering card is one of the few commercial illustrations I've created exclusively in oil paints.

PHARAOH LIVES! *(left)*
Drawn by my friend Gabe Hernandez, then painted by yours truly, this card art was used for Eagle Games's Age of Mythology board game, based on the popular PC game by Microsoft.

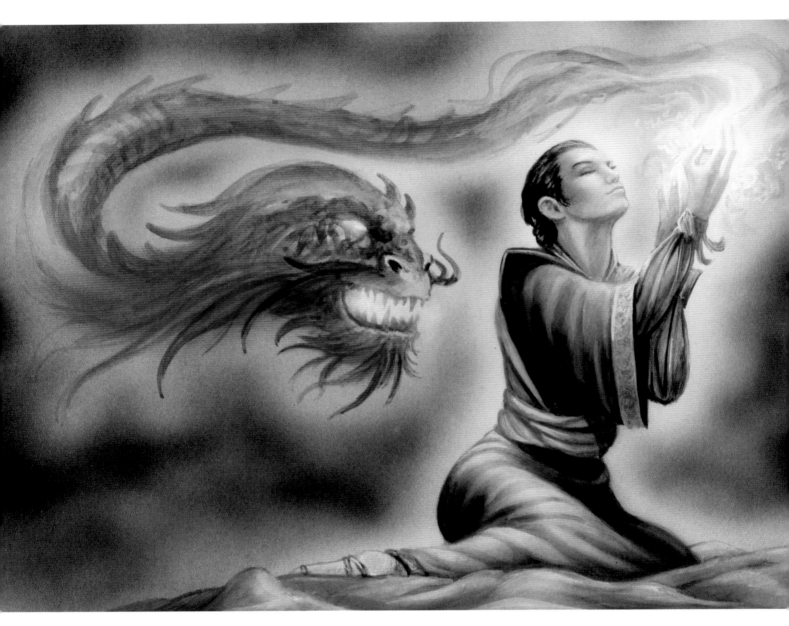

MAGICALIGHT

If only our thoughts and dreams
were so easily conjured.

MAGICALIGHT *(sketch)*

CONJURESS

RPG illustration featuring the act of conjuration. Simple changes can really alter the final creation.

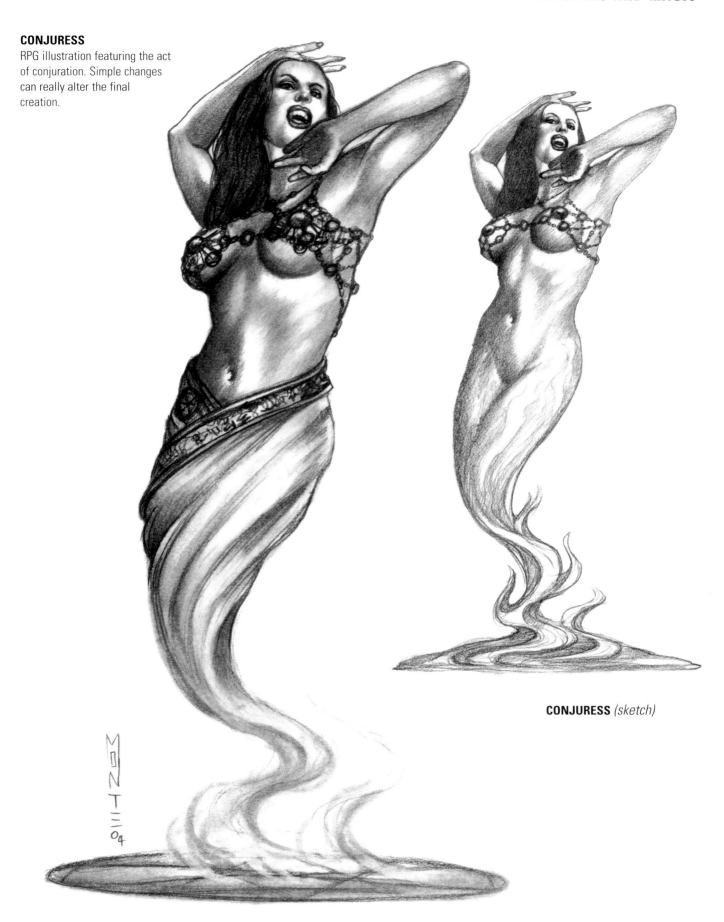

CONJURESS *(sketch)*

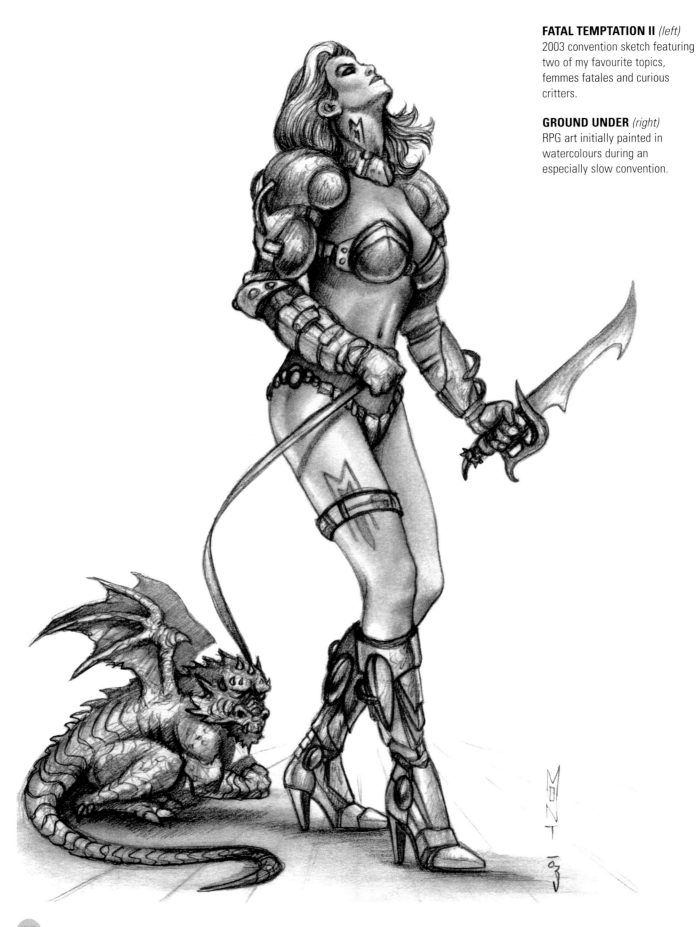

FATAL TEMPTATION II *(left)*
2003 convention sketch featuring
two of my favourite topics,
femmes fatales and curious
critters.

GROUND UNDER *(right)*
RPG art initially painted in
watercolours during an
especially slow convention.

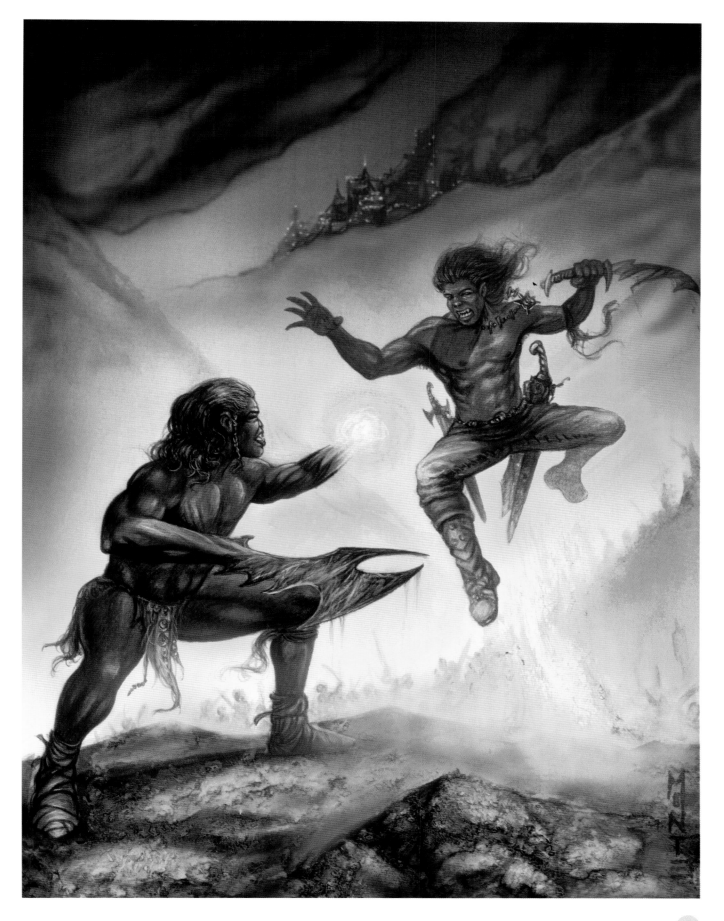

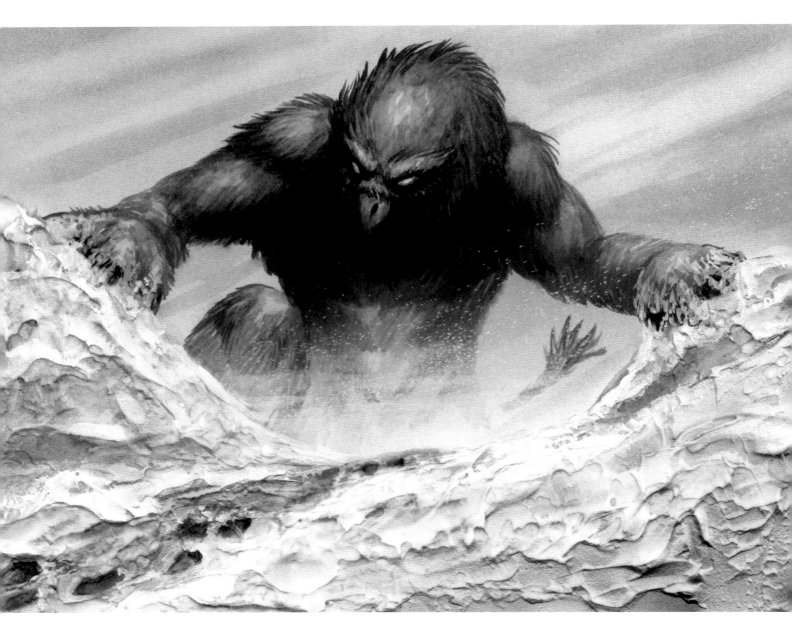

ICESLAYN

Using cool cold colours in this image helps illustrate the tundra-like setting for this Warlord CCG card. Of course, illustrating a bird-headed yeti-like creature is tricky in itself . . .

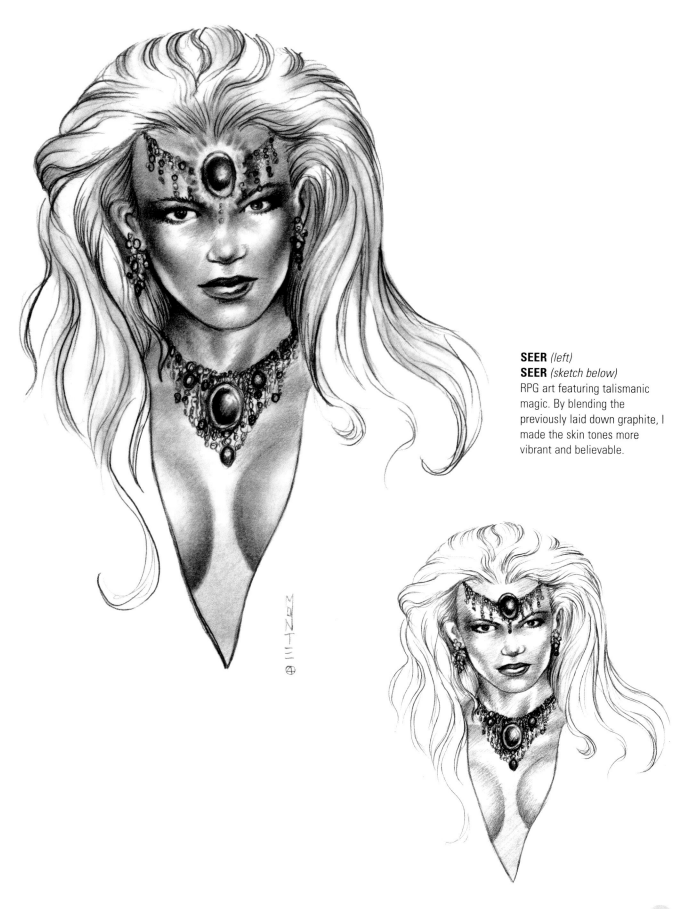

SEER *(left)*
SEER *(sketch below)*
RPG art featuring talismanic magic. By blending the previously laid down graphite, I made the skin tones more vibrant and believable.

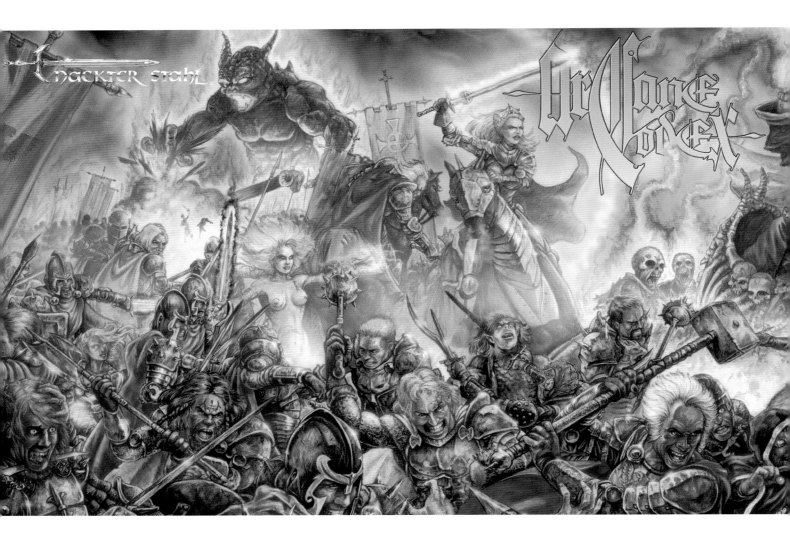

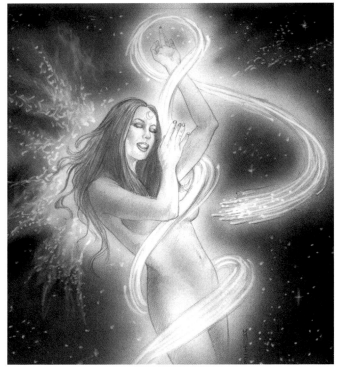

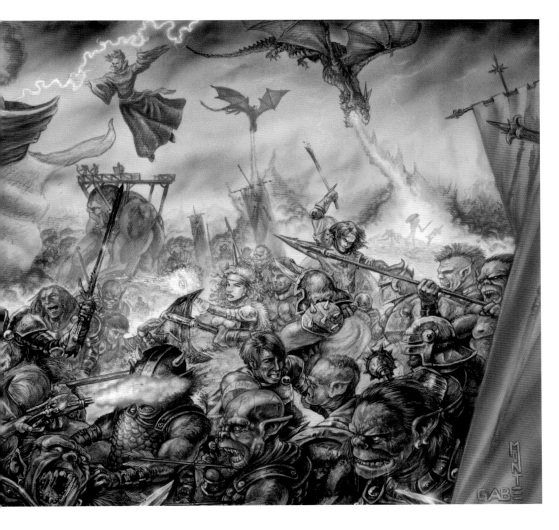

UNLEASHED!

The largest, longest, most detailed and most complex illustration I have ever tackled; the original painting has over 120 hours of work in it. To help with speed and creativity, the dynamic underdrawing and concept were done by Gabe Hernandez. Although this four-panel Game Master screen may look like a haphazard mêlée, in actuality almost all of the forty characters had full descriptions of what they looked like and whom they should be fighting. This assignment was offered to me after a very unprofessional and unreliable illustrator backed out on the job after it was begun, and left the client hanging!

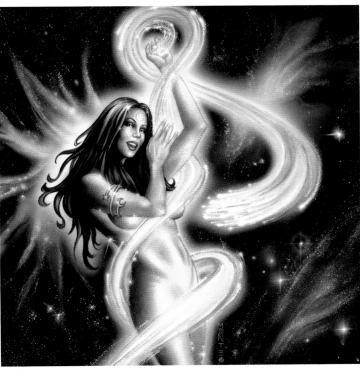

URANIA SINGS

Model: Diana Knight

This CD cover for the band Emerald Rose features Urania, muse and seductress of the astronomer. These images show the stages from initial concept to tight black-and-white comp. to completed art. Part of the enjoyment of this project was to illustrate the title track based on the song's uniquely visual lyrics.

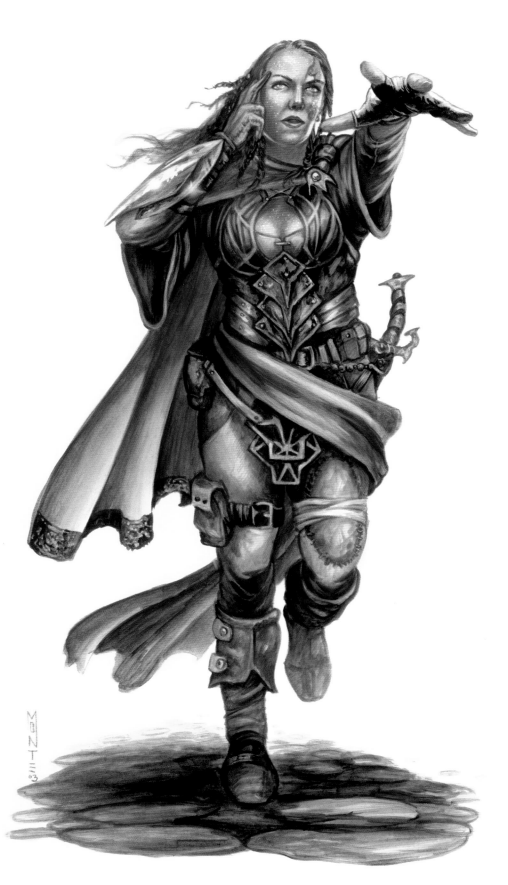

EULAD THE WILDER *(sketch above)*
EULAD THE WILDER *(left)*
Model: Christine Richardson
New Dungeons & Dragons character
class done for Wizards of the Coast in
acrylics on illustration board.

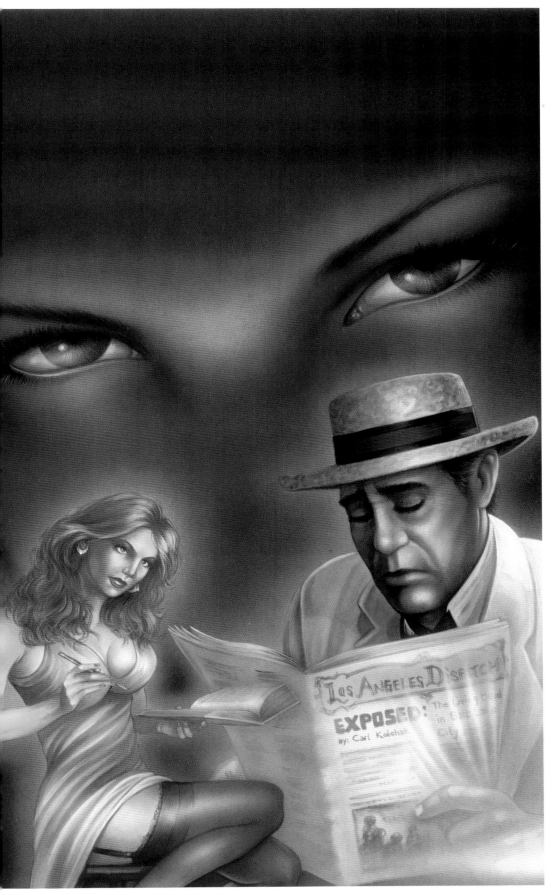

KOLCHAK'S SEDUCTION
Images from a *Kolchak: The Night Stalker* comic-book cover for Moonstone Publishing. The head shot of the demon in the background was deemed too much of a plot giveaway, so the final showed a seductive and sinister eye close-up instead.

METHODOLOGY

In this section I demonstrate the methods and materials I use to complete a typical drawing and painting. These are only one artist's methods, and are by no means necessarily standard — there is no standard for creativity.

DRAWING MATERIALS: *DREAM CREATURES*

I prefer the Bristol Vellum finish by Canson as the paper for my drawings, and typically use an HB lead pencil; some artists prefer multiple hardnesses, but I find I can achieve what I want with HB. For areas such as hair I sometimes use a mechanical pencil to make the tight lines, so I'm not having to sharpen my pencil too often. Erasers — such as electric, hard pink and kneadable — are all necessary for the creation of highlights within the drawing. Lastly, blending stumps and facial tissues are needed for blending effects in the skin-tone areas.

Graphite

After doing the initial sketch, I usually start the formal work from the head down, as the portrait will make or break any drawing that has a likeness or face involved. This also illustrates the difference in tones between those of a finished section and those of a section that has been only 'roughed in'. Notice that I've already started laying in rough tones in the skin, but have done no blending and no building of heavy tones.

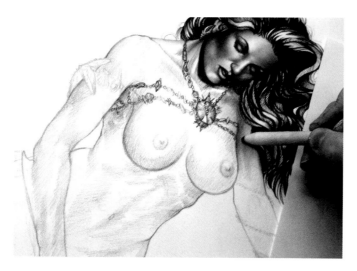

BLENDING TONES
I retain a piece of clean paper under my drawing hand at all times to keep other parts of the illustration clean; this is a very good habit to get into. The blending stump is very accurate for shading, but be careful when working on large soft areas of skin in case you leave unwanted defining marks on the surface. This method is all a matter of building multiple layers of shading to reach the desired pencil values.

BLENDING SKIN TONES
I like to wrap a piece of facial tissue (not the kind impregnated with lotion) around the tip of my blending finger to achieve softly blended skin tones. The tissue keeps the grease from my finger off the illustration, and blends the graphite much more smoothly. This method of blending can take five to ten applications before you reach the desired values, since the tissue is also removing some of the darker values. Keep adding more graphite, then blending, over and over, until you are satisfied with the areas you're working on.

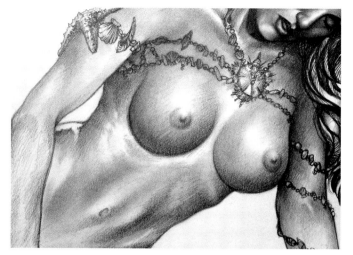

BUILDING TONES

As mentioned before, this approach is all about building tone and value. In this image you can see some areas of the body are getting closer to the values used for the face and hair. Some of these areas are not quite as smooth, because I have not been blending these areas as softly with the facial tissue. The final drawing will show these areas darker and smoother. Notice how the necklace details have become soft and smudged from the tissue, and have no highlights. Once the surrounding skin has been done, I will revisit those areas and re-darken the shells, using the eraser to pull out highlights on these items.

BLENDING STUMPS

These come in many different shapes, I generally use smaller stumps for face and hair areas and bigger ones for the larger skin areas. I never clean or sharpen my stumps, since I like them to have ground-in graphite already on their tips, so I can use this to shade and actually draw with as well. The softer or larger the area of shading, the softer the approach needs to be. In other words, use the facial tissue for long smooth gradations, such as the length of a leg, and use small stumps for shading around noses and eyes.

KNEADABLE ERASER

This little bit of gummy substance is invaluable to the artist. I like to shape my erasers into flat blades and etch the highlights into my drawing, as seen in this image. Repeatedly bringing out the highlights in your drawing, at all stages, keeps them bright and strong. If an area gets too dark, you can dab your kneadable eraser gently into it to remove the heavy graphite.

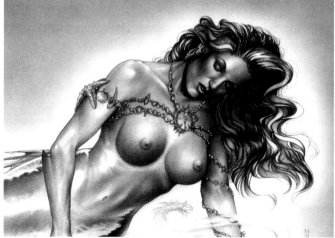

DREAM CREATURES

In this final image, you can see I have continued to darken areas of shadow and, using both a kneadable and an electric eraser (see page 79), have brought highlights that were dull back to the desired brightness. Using a blending stump, I added the smoky swirls of the draconic creature issuing forth from the shell. Lastly I deployed just a little bit of grey paint in my airbrush to slightly darken the area behind the figure. (I could have achieved the same effect with pencil and tissue, but this method is quicker for me.)

PAINTING MATERIALS: *HEAVENLY FURY*

This project, *Heavenly Fury*, was half of a double-sided card illustration featuring a warrior angel on one side and the same character in a much darker aspect on the other. (The matching illustration, *Knight Fire*, is shown on page 82.) The model was Diana Knight, who furnished me with outstanding reference photography for the needed poses. It was up to me to create any additional armour, clothing, special effects and lighting – and the setting. The angel's armour designs were from Tony Swatton, the 'blacksmith of Hollywood', whose armour and swords appear in almost every major epic movie made in the past ten years.

After the sketch had been approved, I redrew it onto Crescent 215 illustration board. Because of the mixed media I employ, I like my surfaces to take paints such as acrylics and watercolours, but to be not too rough for airbrush or eraser techniques. For this I find the 200 series of Crescent papers very reliable.

At this stage of an illustration I do a fairly complete rendering, including shadows and necessary areas of information to capture the model's likeness. I don't want the pencil to be so dark that it becomes messy or overpowering, but nevertheless the pencil will show through in some areas of the final work. At all stages of the process it is very important to keep your illustration as clean as possible. I always remove any smudge marks that develop as I go with the kneadable eraser, so these areas do not become ground into the surface and become permanent.

With the drawing done, I am ready to begin painting. This next stage can be done using either watercolours or acrylics, depending on how comfortable you are with either medium. I used watercolours as my underpainting method for about five years, but now I prefer acrylics. Watercolours are a bit more forgiving, and can be removed and thinned more easily with water applications if you make a mistake. However, they dry lighter than they were when wet, and are also more difficult to use when building multiple colours. I recommend watercolours for novices, and that you graduate to acrylics later on.

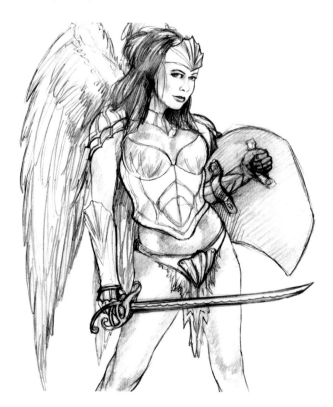

FURY SKETCH 1
This first sketch was deemed too mild and static by the client. Although it looked nice, it didn't convey the action this piece needed.

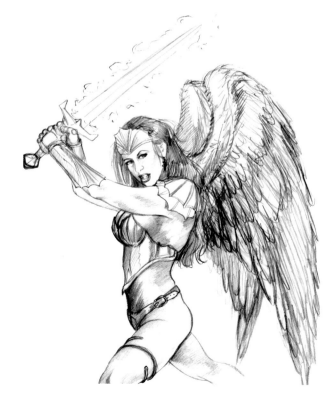

FURY SKETCH 2
This new version captured the dynamic motion the client was after, and made a better sister-piece to its demonic counterpart.

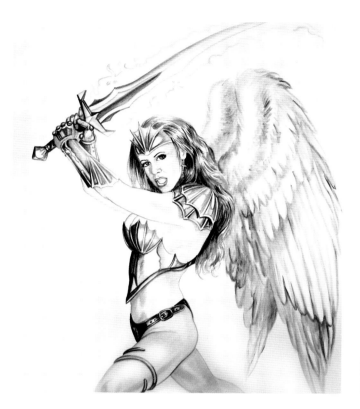

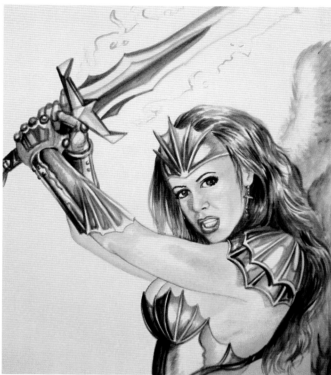

UNDERPAINTING

To minimize the need for masking film (commonly referred to as frisket), I hand-paint as much of the underpainting as necessary. The example shown here was done with tube acrylics. Dark shadows, hard edges and any necessary textures can be developed during this stage. In the flesh areas, I dilute the paints and paint very lightly.

UNDERPAINTING CLOSE-UP

After the underpainting has dried, take a kneadable eraser and remove any left-over pencil marks you deem no longer necessary. Most of the pencil areas should by now be either covered or indicated with paint – this will also help prevent your inadvertently removing your pencil marks during any masking, or frisket applications.

Airbrush

The kind of airbrush an artist uses is strictly a matter of personal taste. Manufacturers like Holbein, Iwata, Badger and Pasche, among many others, sell quality products. In my fifteen years of airbrushing I think I have used pretty much every variety on the market, and I currently own at least 15 or 20. Different guns have different uses: large guns are best for murals, small ones for illustration, and durable ones for long hours of repeated use, as in textile airbrushing.

A skilled airbrush artist can of course create beautiful work with a brush of almost any quality, but sometimes having a really fine tool makes the job that much easier. In my opinion, the best-designed airbrush is the little known Toricon YT-02, made by Holbein. This brush isn't as renowned as Iwata's products (also good), but is the most durable, versatile and capable airbrush I have ever come across – I can attest to this since I've been using the exact same one day in and day out since 1990! This brush creates the finest line possible, has two sizes of swivelled and covered paintcups, and is the only brush designed to be completely submersible in cleaning fluid. All parts are stainless steel except the platinum needle, which has a very long taper for better control. Another defining factor of this brush is the gun-like trigger under the body, which is comfortable when you're airbrushing for long periods of time.

Additional tools include an X-Acto knife (for frisket cutting), erasers (for highlights), small brushes (for hand painting), cleaner and water. I also use a texture gel by Liquitex which is excellent for texture-building. I attach an inline moisture trap as a second line of defence against water condensation in the airbrush line. A large blot of water from the airbrush can create real problems if it shoots out of your gun onto your almost finished painting!

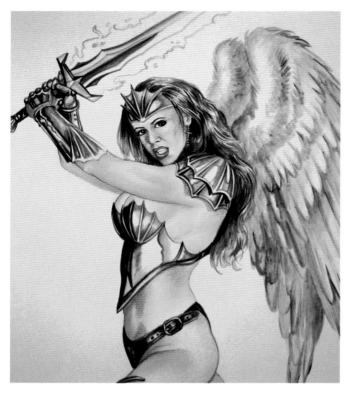

AIRBRUSH: STAGE 1

This image shows the very first light application of flesh-coloured paint. Depending on the skin tones you seek, this can vary through differing shades of sepia, brown, burnt and raw umber and sienna. Overspray at this stage can be removed with an eraser to keep the areas surrounding the skin tones free from unwanted paint.

Paint colours differ by manufacturer. For airbrushing I prefer a pre-mixed liquid paint formulated specially for this type of application. The paint should be free of dried particles, which can jam the airbrush mechanism, and should have the consistency of milk. I usually dilute my airbrush paints with one drop of water per three drops of paint; this helps reduce graininess in the spray and minimizes the problem of paint drying on the needle's tip. For my own personal taste I find the Aeroflash acrylics, made by Holbein, to be the best on the market: colour consistency, lightfastness, density and brilliance are all exceptional, and the bottle has a ceramic ball inside to help stir the paint. There are many other quality paints on the market, however, so I suggest you experiment to find what best suits you.

Note on airbrushing. Remember, airbrushing involves micro-thin layers of paint, so don't try and build up all your colours at once. Paint your layers light and even to avoid overspray and splattering of paint. Always test your airbrush away from your illustration, so you don't inadvertently spray a large error into your painting.

Paint Removal Techniques
USING A HARD ERASER

Learning erasing techniques is absolutely critical for this method of painting. Erasing is often thought of as being merely a way to remove your mistakes. Not so! In this image you can see how I'm creating much-needed highlights with the eraser, as planned all along. To keep highlights vibrant, with the colour of the paper showing through the paint, they should be re-erased after every stage/colour of paint application. Utilizing these 'etching' techniques, you can create far more effects than you could by merely adding paint.

For this method, a hard eraser, such as the pink hand-held eraser in the photo, is perfect. For tighter etching effects – such as in the face, where accuracy is important – try cutting the tip of the eraser at an angle to create a more precise instrument.

USING A KNEADABLE ERASER

Creating highlights can be done using any of several different methods, the subtlest being with the kneadable eraser – the artist's best friend! In areas where you want softer highlights, the hard pink eraser is not ideal. Carefully brush the eraser across the highlight area with repeated light strokes until the desired effect is achieved.

USING AN ELECTRIC ERASER

I find the electric eraser an invaluable tool for both my drawings and my paintings. I recommend the Sakura electric eraser. Designed for architects, this eraser is portable, powerful and accurate. Although it's not suitable for large subtle areas, it's the tool to use when creating tight paint-removal effects.

AIRBRUSHING CONTINUED

Now that I have removed any unwanted paint from my skin-tone highlights, I can continue to paint. The addition of red to skin tones is vital, as this is what gives the figure life. The more near-surface blood-supply an area of the body has (muscles, noses, cheeks, etc.), the redder and more lifelike that area should be painted. Areas where bones are close to the surface, such as knees and elbows, likewise often have more reds in them. Sections of the body that have more fat or soft tissue, such as the breasts, generally appear lighter.

Don't be fooled by this photo showing my finger resting on top of the airbrush. As is common with double-action airbrushes, the trigger for this one is 'gun' style, underneath the brush body.

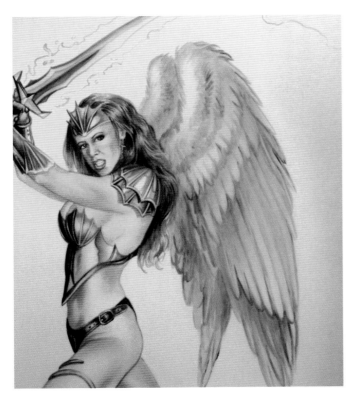

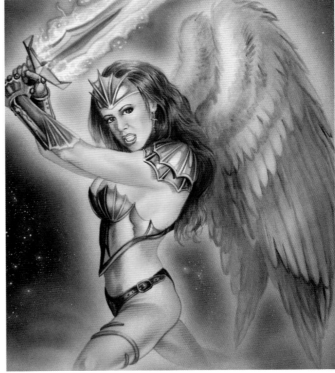

BACKGROUND APPLICATION

Because this figure will have a glowing aura, there is no need to use a frisket to cover the foreground. If the background had to be tight around her, it would be necessary to cut a mask. In this stage, you can see that some subtle browns and greys have been airbrushed onto the wings.

Finally, I begin to apply paint evenly in thin layers to build up my background. You can see that, although the final effect will be deep dark space, I don't try to paint it all at once. Painting further back from my board, and keeping the brush moving, I spray paint slowly and evenly as I build to my desired effect.

Note on background spraying. Often backgrounds are large and require considerable paint application, which puts millions of unseen paint particles into the air. Always wear some sort of mask, preferably a charcoal respirator, to keep these particles out of your lungs. Unlike inhaled smoke particles, inhaled paint particles permanently adhere to the inner lung wall, and never come off. Although acrylics are not inherently toxic, it is best not to paint a mural on your lung wall!

BACKGROUND CONTINUED

After the background tone has been created, I turn down the air pressure of my airbrush in order to spatter stellar effects onto the background. Also, I apply areas of white to the foreground to give my angel the effect of rising out of or standing in celestial clouds. I use the electric eraser on areas surrounding the sword hilt to create a magical energy effect.

Although the illustration is really starting to take shape, the most important stage has yet to come – the hand painting of the final highlights and shadows.

HEAVENLY FURY FINALE! *(right)*

Though most paint applications are done before the final stage, the completed image shows the importance of revisiting almost every area of the painting to add those essential concluding touches. For this I prefer either white acrylics or gouache, which is a very opaque water-based paint. In this stage, the areas that need attention are usually the highlights on eyes, flesh, armour and any parts that catch light. This is when the illustration really comes to life, as the subtle touches are added, whether by hand painting or, for the metallic special effects, by airbrush.

Important note. Don't airbrush what you don't have to, and don't rely on the airbrush when you don't need to. The airbrush is a great tool for light effects, large backgrounds and subtle shading, especially for flesh tones, but it should not be a replacement for hand-painting techniques or an excuse for not learning them. Don't make the same mistakes I did in my youth!

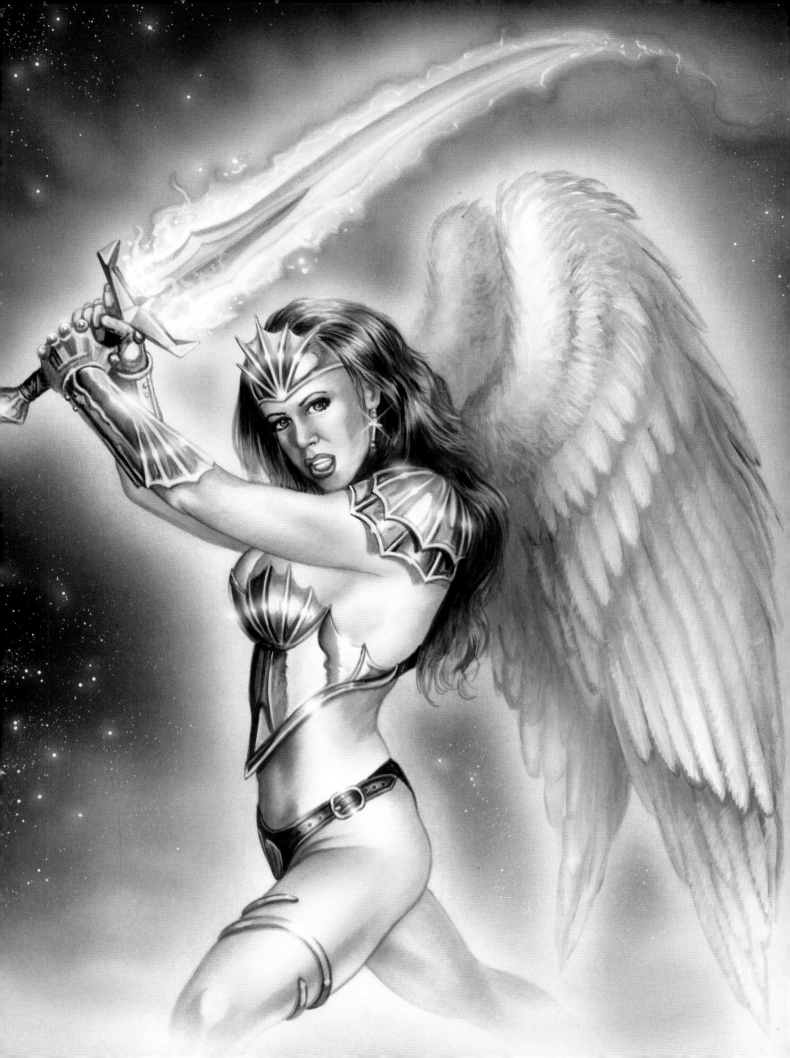

KNIGHT FIRE

Model: Diana Knight
The counterpart to *Heavenly Fury*, showing Diana's darker side – a side we all possess, though some have it better hidden than others!

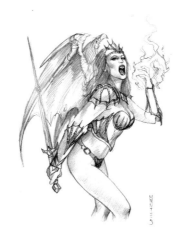

KNIGHT FIRE UNDERDRAW
KNIGHT FIRE SKETCH

Often backgrounds and special effects like fire need no more than to be visualized during the underdrawing phase, but it is in this phase that the all-important determination of the light source must be made. This is crucial in a piece like *Knight Fire*, as it is the light and fire that help give the painting its flavour.

KNIGHT FIRE UNDERPAINT

Even though I will airbrush over the underpainted work, most of the subtle details established in this stage will still be evident in the final art. Notice that I've already begun to indicate the illumination effect of the fire on the nearby flesh; in this way I keep in mind the all-important light source.

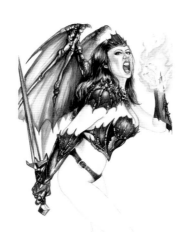

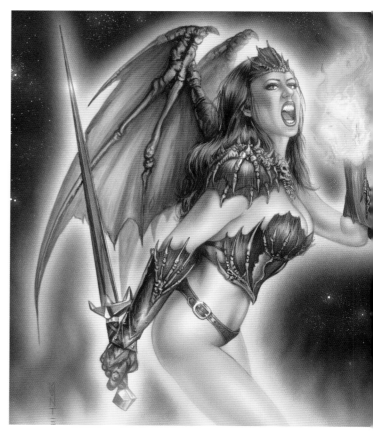

KNIGHT FIRE FINAL

In the finished piece you see not only the final effects of the light source from her hand but also the way she appears almost to rise from the fire. I incorporated that element to tie this picture in with the similar background and effect of *Heavenly Fury*, its companion piece.

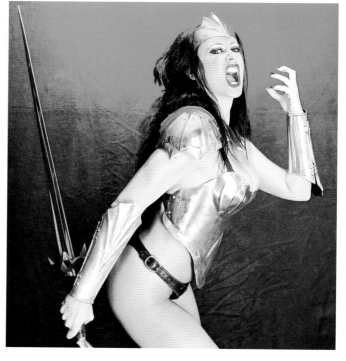

REFERENCE PHOTOGRAPHY

People often ask me if I work with live models. I seldom do so unless I am attending a figure-drawing class. In today's world, photography offers much more expediency and portability than a live model. Although the camera can often flatten what we see, reference photography serves as a guideline for proportion, lighting and foreshortening. Most illustrators who specialize in painting people realistically make frequent use of reference material – names like Boris Vallejo, Julie Bell, Alex Ross and Olivia come to mind. It's our job as artists to expand, elaborate and bring to life in unworldly ways the photos we use as a starting point.

COMIC-BOOK-STYLE ILLUSTRATION

DEITY COMIC-BOOK COVER
The following images show the progression from sketch to completion of a traditional comic-book-style illustration.

DEITY
Since the clients weren't sure how I would approach the art – it is very unlike my more realistic artwork – this drawing was done to show them the composition and style of the final piece.

DEITY INKS
Inked by Chachi Hernandez, this piece is almost ready for paint. Note the thicker ink lines on the main subject, to bring her closer to the viewer.

DEITY COLOUR
Although the colours in this piece are airbrushed, they needed to appear more like the computer-applied colouring popular today, vibrant yet controlled.

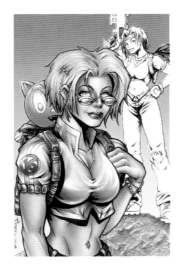

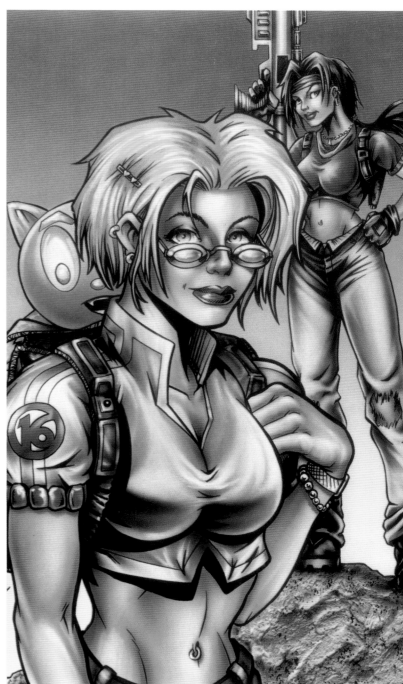

DEITY FINAL
This comic-book cover was never in fact used by the publisher, but the stages shown here serve to illustrate the progression from concept to cover art.

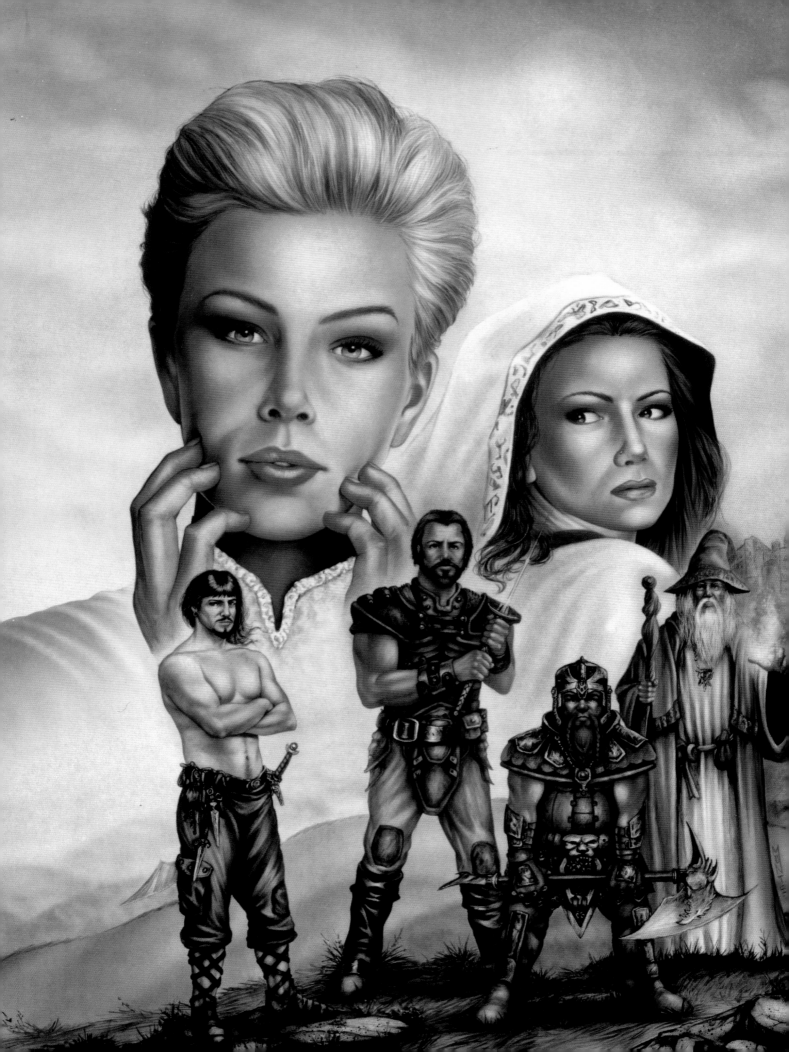

MENAGERIE

GUARDIANS OF THE FLAME
(left)
Cover for a Baen Books novel.
I feel it's necessary to read the
book whenever possible before
tackling a cover. This gives me a
better feel and insight into the
characters and settings I'm
being asked to create.

THRAXAS *(right)*
Cover for a Baen Books novel.
The art features a female half
orc. It's often tricky for an artist
to meet the needs of a specific
project. This character had be
strong and tough as well as
sexy, but not so attractive as to
look totally human — hence the
red skin tones.

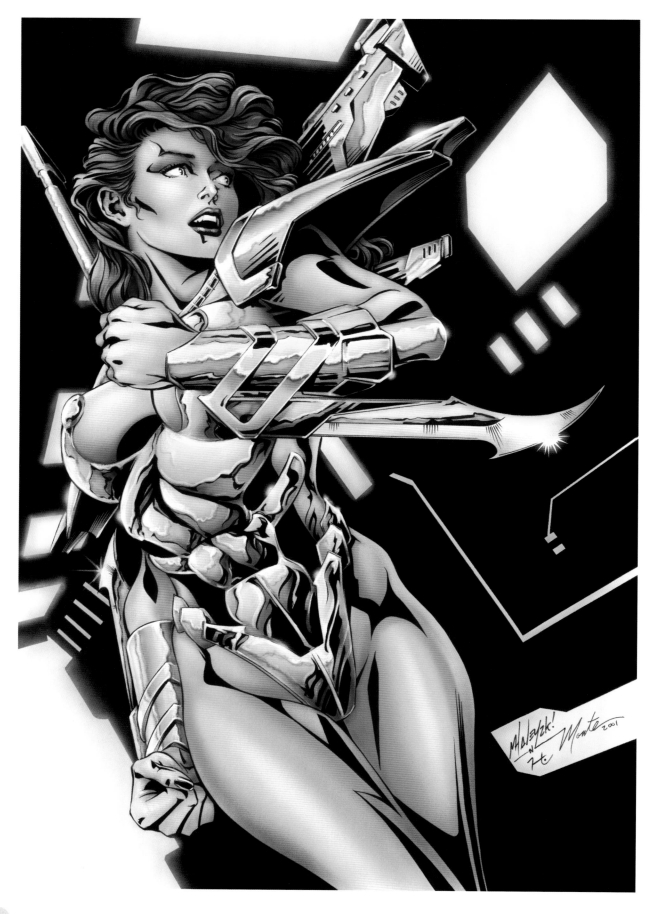

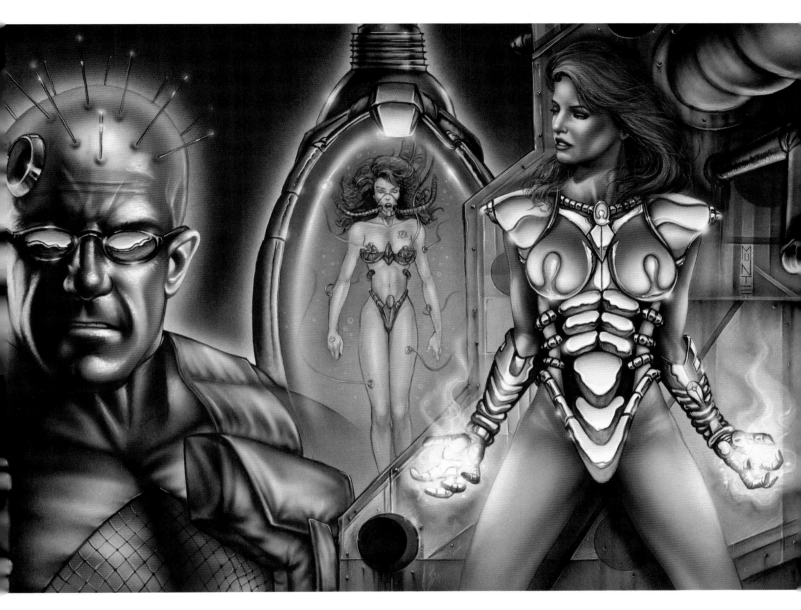

CICI PIN-UP *(left)*
Drawn by comic artist Matt Haley and inked by Chachi Hernandez, this piece exemplifies the traditional comic roles of penciller, inker and colourist (me).

CICI *(right and above)*
Select images from a four-issue comic-book mini-series. Although it took over five years for the self-publisher of this series to bring his dream project to life, he never gave up. It's very difficult in the modern world to make your dreams come true, but they certainly won't happen if you don't make them happen.

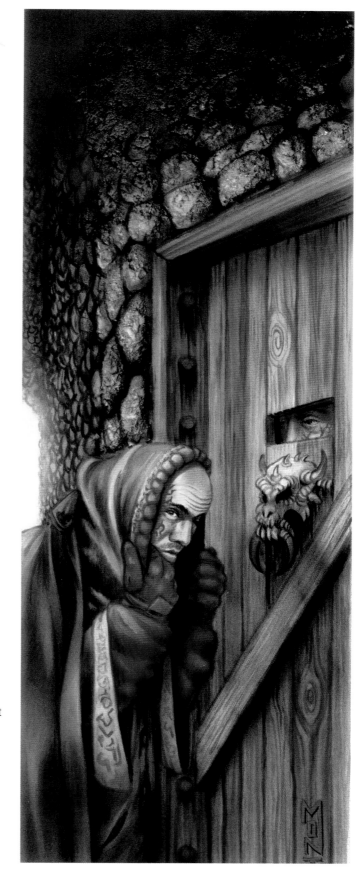

UNEASY PREY *(left)*
For compositions such as this RPG cover, I often shoot photographic reference to help capture the moment. This scene called for the main martial artist to appear as if her speed and reflexes were much more developed than those of her attackers. Ah, if only women were this fast when getting ready in the morning!

HELPING HAND *(above)*
Advertising illustration for telecom giant Qwest. Created in just brushed acrylics, with no other media, this piece represents a bit of a rarity for me. After I'd received a frantic call from the art director, the art was done in less than a day, start to finish. Good, fast and cheap – you can have any two, but not all three!

SECRET SOCIETY *(right)*
Dragon Magazine editorial illustration.
Knock twice or pay the price!

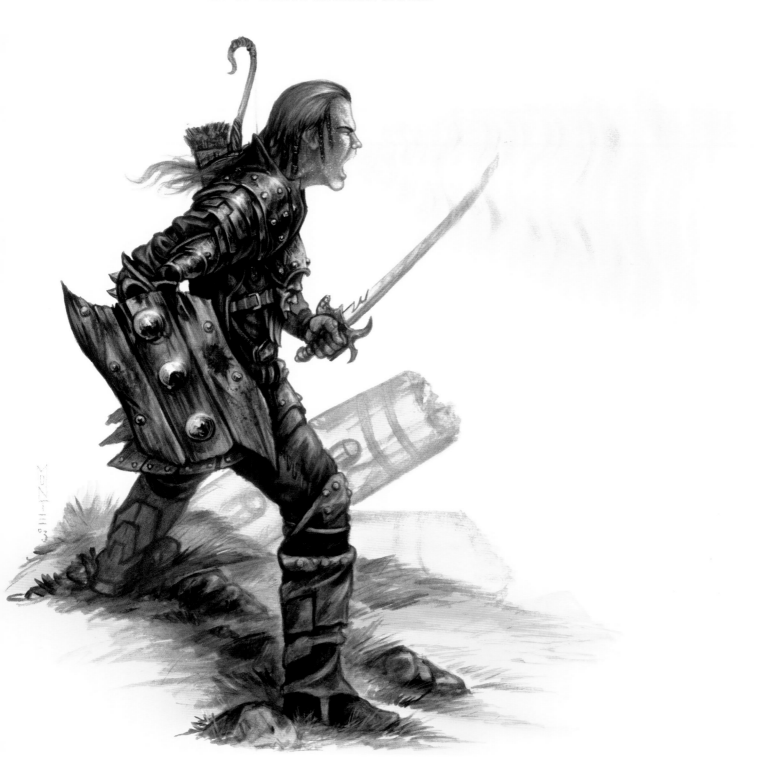

HEAR ME! FEAR ME!
New character class for Wizards
of the Coast's Psionics
Handbook.

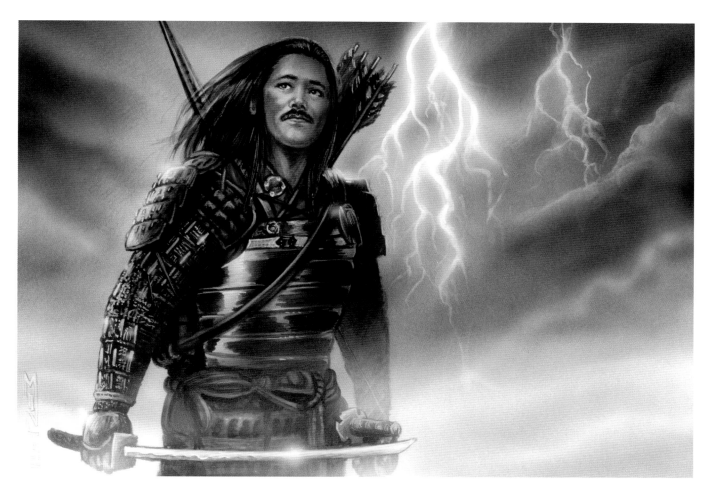

HONOR GUARD *(above)*
HONOR GUARD *(sketch right)*
Legend of the Five Rings CCG art. I never know where my next model might come from. Jerry, the model for the samurai shown here, is also a genius at fixing copiers.

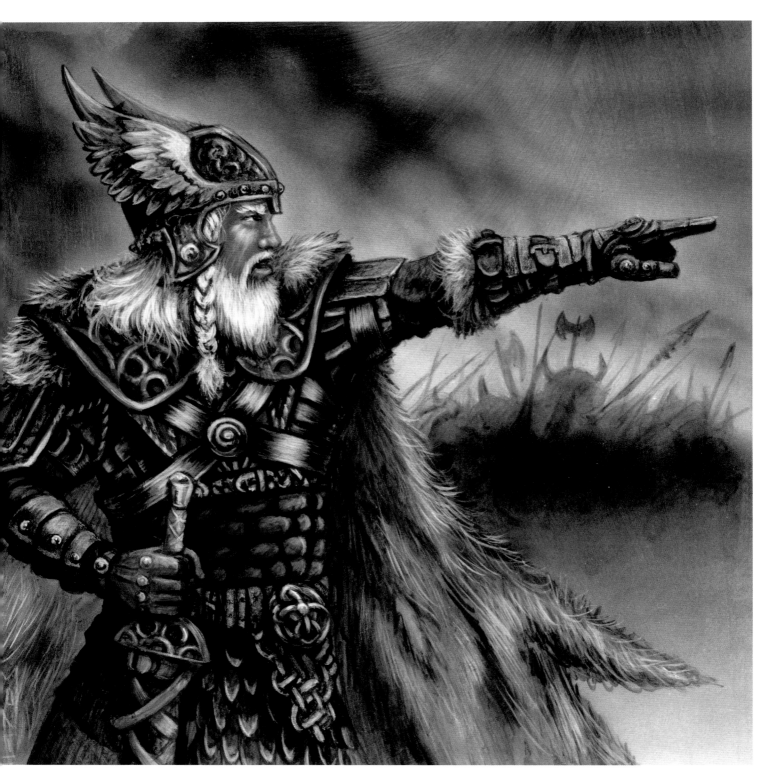

COMMAND
Very Odin-like, this piece was done to illustrate the cards' function in the board game Age of Mythology.

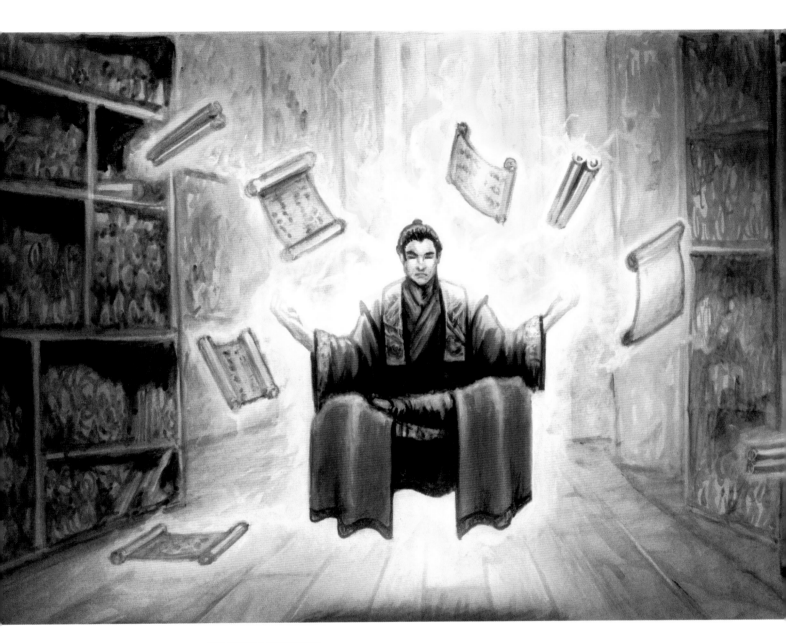

LEARNED LIBRARIAN
The original art description for this Legend of the Five Rings card was not very exciting. My suggestion was to show the subject levitating, surrounded by whirling open books, as if learning by magical forces . . . obviously a more dynamic approach than showing someone just standing in a library.

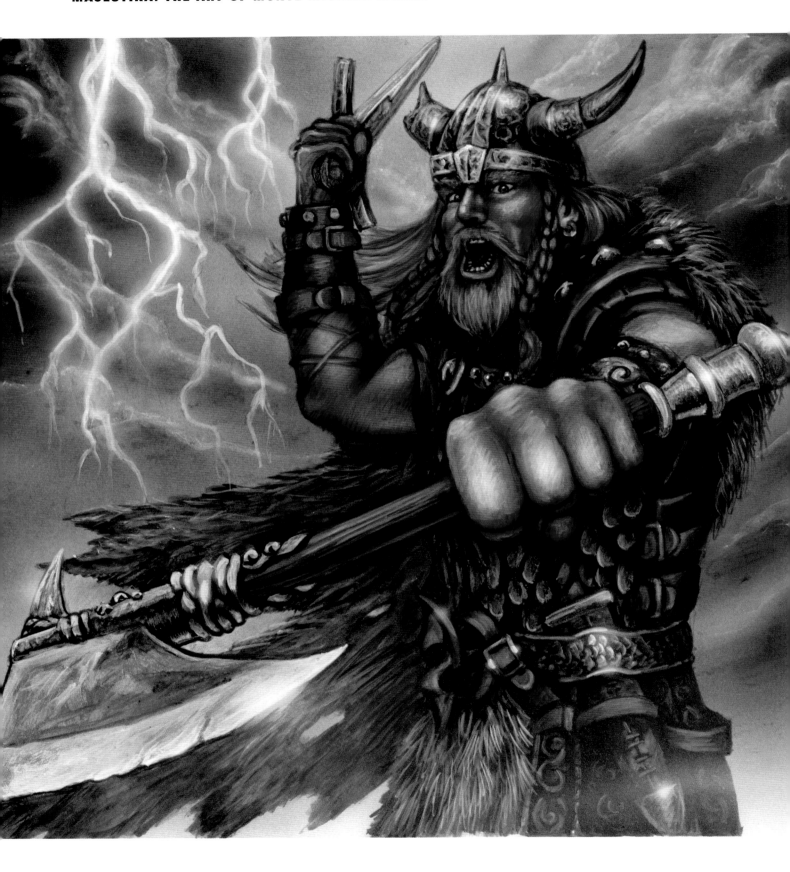

ATTACK *(left)*
The hand and axe were enlarged
in this painting to add a more
'in-your-face' dynamic.

GATHER *(above)*
I used an artists' gel containing
gold mica flakes to enhance the
look of the buried gold.

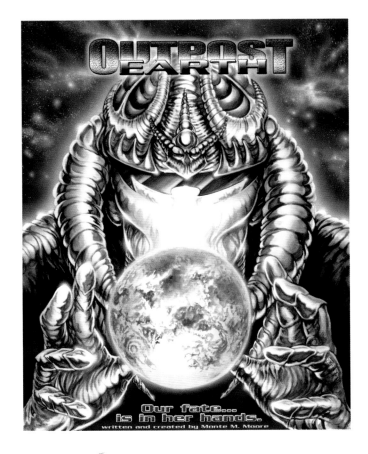

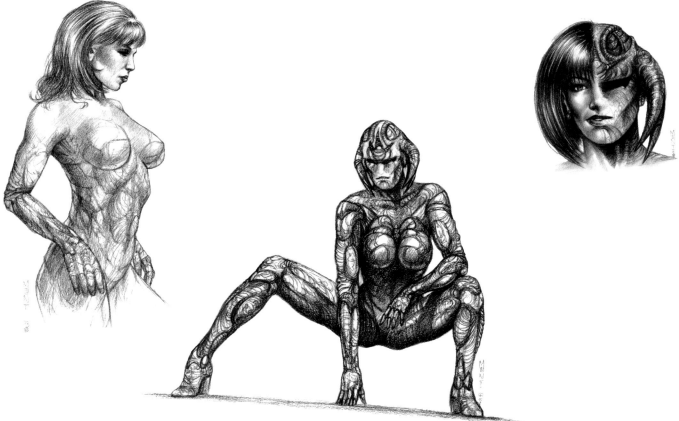

OUTPOST: EARTH *(left)*
These images are from one of
the many stories I have written.
Since creativity is inherent in
artists, I think it's natural to
create stories as well as paint
and draw. This particular
storyline focuses on a female
cyborg who is able to disguise
herself as a human using a
'hologuise'. I hope one day to
see my stories in print, comics,
television or film.

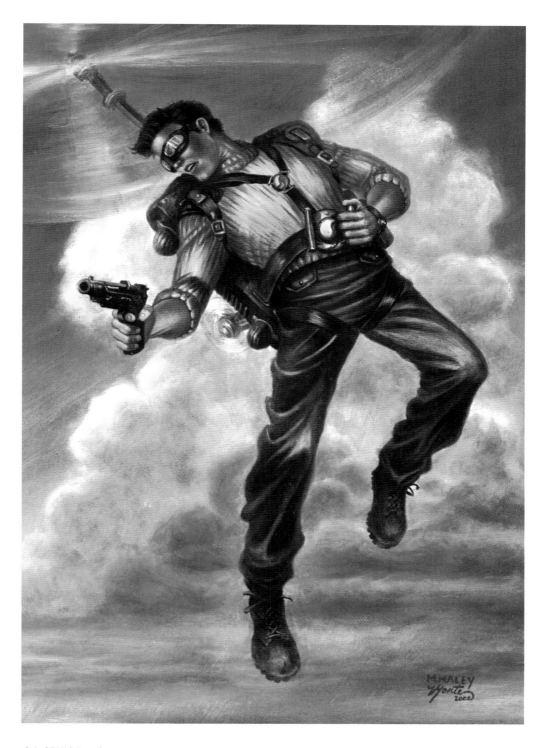

G.I. SPY *(above)*
A collaboration between myself
and comics artist Matt Haley.
The initial drawing was done by
Matt, then I painted the final
version with oils. I wanted the
image to capture the feel of a
1940s pulp magazine cover
rather than be a slick modern
treatment.

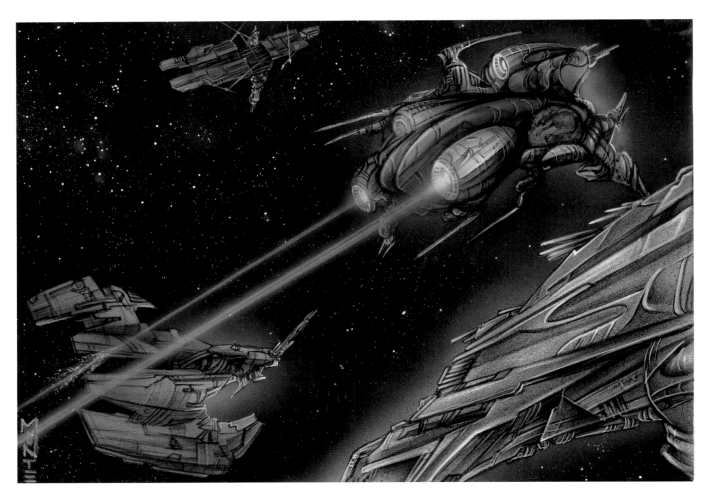

FIRESTORM *(left)*
CCG illustration for the epic sci-fi card game Firestorm.

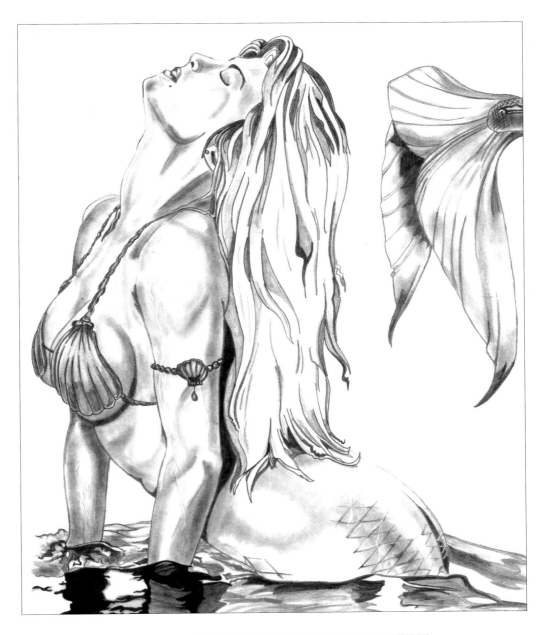

X-TREME *(far left)*
PlayStation 2 box art for Phoenix Games. The concept art for this project was done on an aeroplane. I try to make the most of my time.

DOOMSDAY RACERS *(left)*
As reference for covers like this PlayStation 2 box art, the artist is often given only small screenshots of the game. It's up to the artist to create an illustration that will make a potential customer pick up and purchase an untried game.

HOMAGE *(above and right)*
It's very flattering when people get tattoos done of your art or if, as in this case, they copy it in an attempt to improve their own artistic abilities. This work was done by Josh Viola, a young artist who is pursuing his dreams to become a professional illustrator. I only wish I'd been able to draw this well at his age!

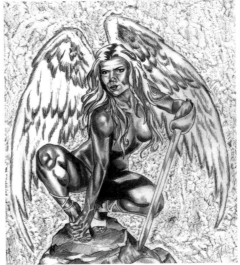

THE MONTE M. MOORE SCULPTURE COLLECTION

These drawings and images represent the concepts from which many of my sculptures have been created, as well as the finished resin pieces. These items are first sculpted in clay; next a mould is created, and then the final products are cast in a poly-resin finish for durability. I feel most fortunate to be working with such fine sculptors and creators, as they have done a wonderful job bringing my visions to life.

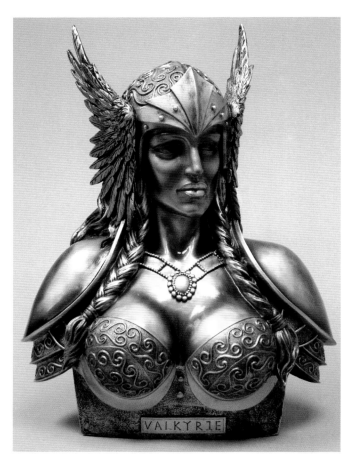

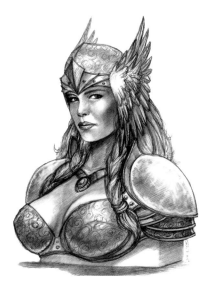

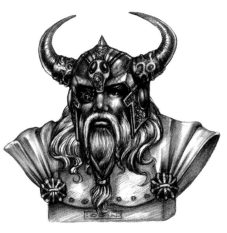

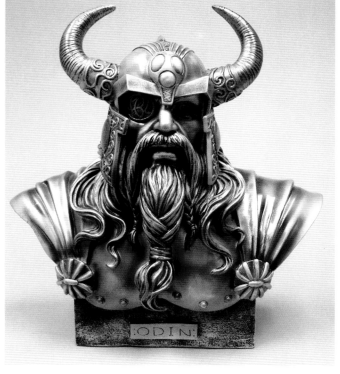

VALKYRIE
(facing page, top)
Sculpture and drawing for
Warrior Maiden Bust.

ODIN
(facing page, bottom)
Sculpture and drawing for Norse
All-father bust.

DRAGON
(right, top and bottom)
Bookend and candle designs.

SERPENTINE *(far right)*
Candelabra.

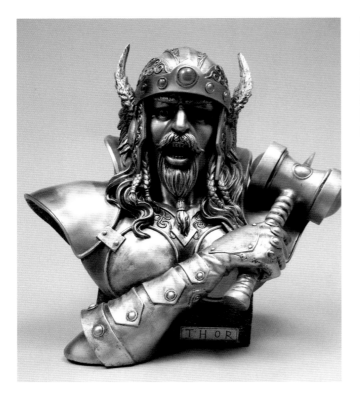

THOR *(left and below)*
Sculpture and drawing for God of Thunder Bust. Designing these Norse busts was a real joy for me as I have been fascinated by Norse mythology for most of my life.

LOKI *(below left and right)*
Sculpture and drawing for God of Mischief Bust.

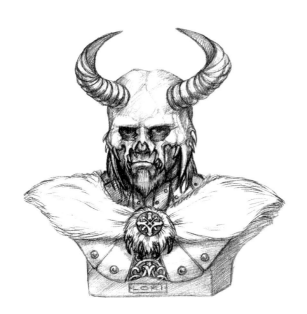

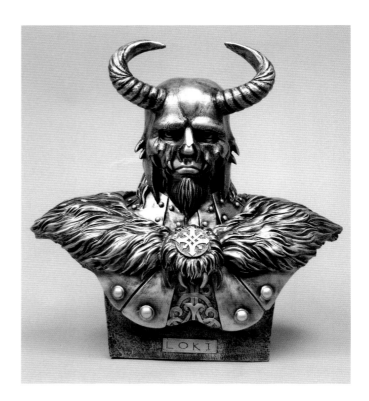

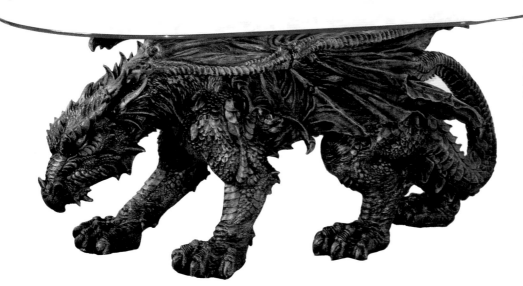

DRAKKEN *(left)*
Having this scary creature as part of your home decor may scare the family pet!

SUNSATIABLE *(right)*
End table.

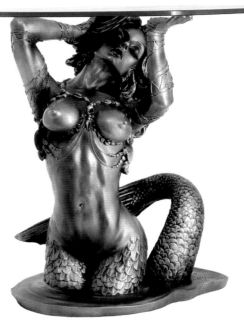

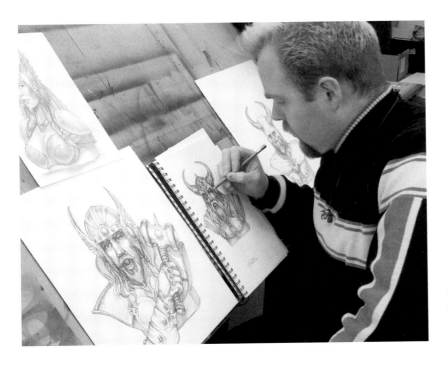

(left)
At work in my studio. It's a tough job…but somebody has to do it!

BLOODLINES

Bloodlines is the title of my fully painted twenty page comic book, which was finally printed in 2004 in comic-book form by Moonstone Publishing. Originally written and created by friend and fellow artist Steve Oatney, we created this project in hopes of Heavy Metal publishing it, I never gave up hope when they didn't want it. I held onto the story for over seven years, then revisited and repainted most of the panels for its final publication. This illustrates why an artist should never throw away their older work…you might need it someday. I now realize just how much work goes into a sequential art story, and have even more respect for artists who create this style of work full time.

This is the one and only graphically illustrated story I have ever created, and given my busy and hectic commercial schedule the last few years, this could be the ONLY story I ever fully illustrate…only time will tell. This story, which was originally called 'A-Bombination', was created and written by my good friend, and fellow artist, Steve Oatney. We got this wild idea back in 1994, to write and paint a story to submit to Heavy Metal. Since I was only working on the painted pages in the evenings, after a full day of other art work, it took until 1997 to get the project ready for actual submission. I wanted the art to have a less polished, and more gritty feel, than my normal work. To accomplish this, I combined some different styles and mediums to give the work a different style. I did this by first drawing the panels in pencil, then inking them with a standard ball point pen for a looser feel. Next I added a layer of loose watercolour and some freehand airbrushed acrylics, and finally some pastel pencil was added over the top. Now looking back, I was searching for a style with this approach, and am not really sure what I found, other than some kind of messy loose art. There were panels that turned out like real gems, and some that should have never been born to begin with. The art that you see in the finished product, is quite a bit different than the original amalgamation. Heavy Metal decided to pass on publishing this story back in 1997, and so until 1993, it collected dust. Unlike wine, art doesn't get better with age, just older. So I revisited the art, and added about one hundred hours back into the various panels, and with hopefully improved skill, brought the story and art to what you see today.

BLOODLINES COVER *(right)*
Cover Model: Nikki Christian

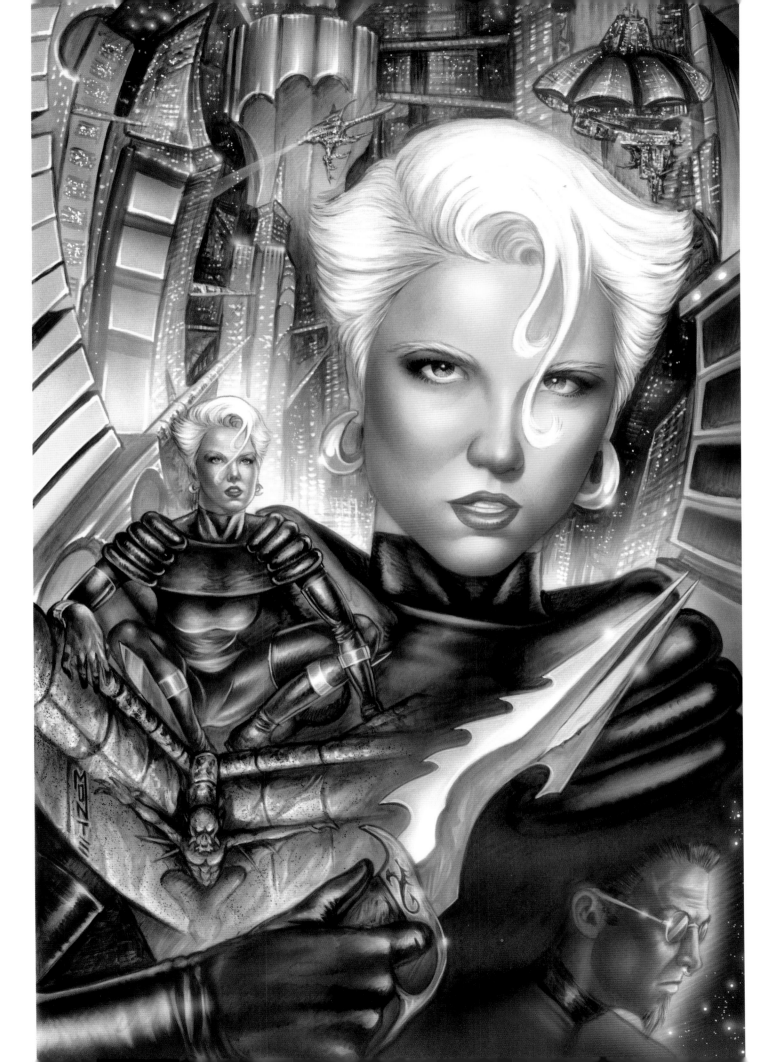

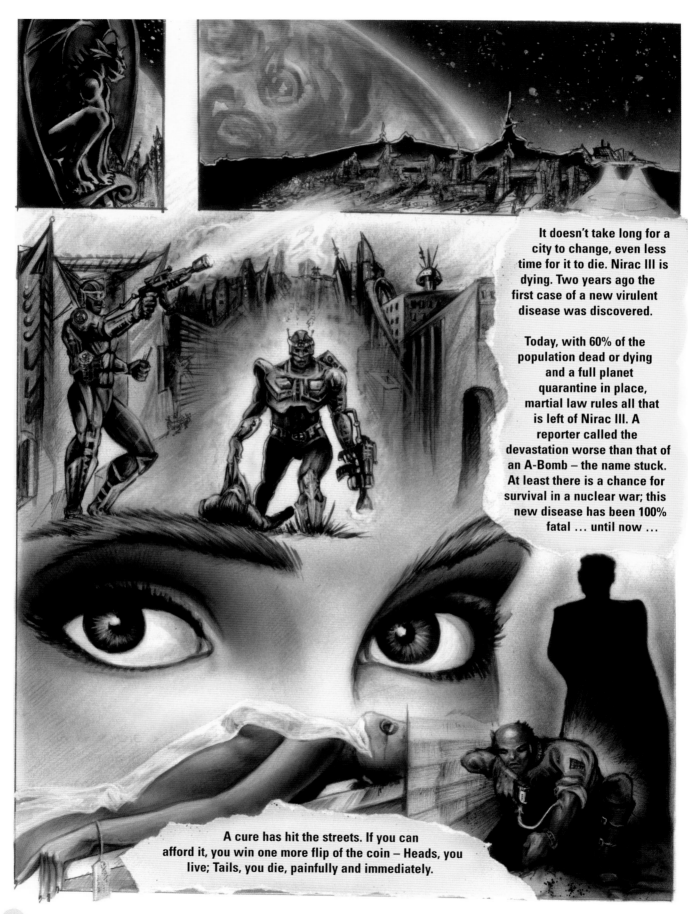

It doesn't take long for a city to change, even less time for it to die. Nirac III is dying. Two years ago the first case of a new virulent disease was discovered.

Today, with 60% of the population dead or dying and a full planet quarantine in place, martial law rules all that is left of Nirac III. A reporter called the devastation worse than that of an A-Bomb – the name stuck. At least there is a chance for survival in a nuclear war; this new disease has been 100% fatal … until now …

A cure has hit the streets. If you can afford it, you win one more flip of the coin – Heads, you live; Tails, you die, painfully and immediately.

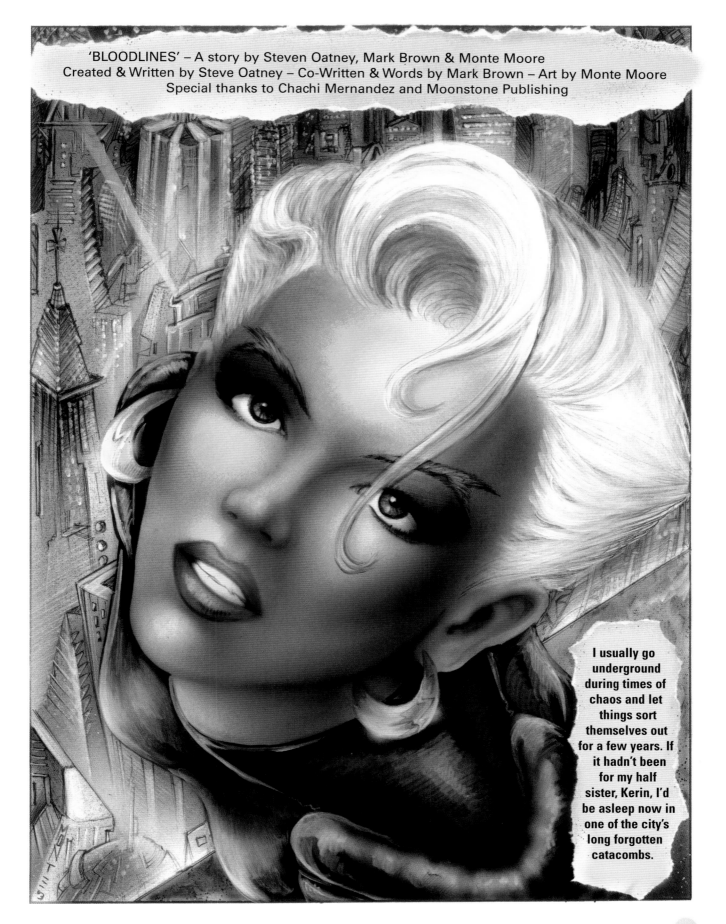

'BLOODLINES' – A story by Steven Oatney, Mark Brown & Monte Moore
Created & Written by Steve Oatney – Co-Written & Words by Mark Brown – Art by Monte Moore
Special thanks to Chachi Mernandez and Moonstone Publishing

I usually go underground during times of chaos and let things sort themselves out for a few years. If it hadn't been for my half sister, Kerin, I'd be asleep now in one of the city's long forgotten catacombs.

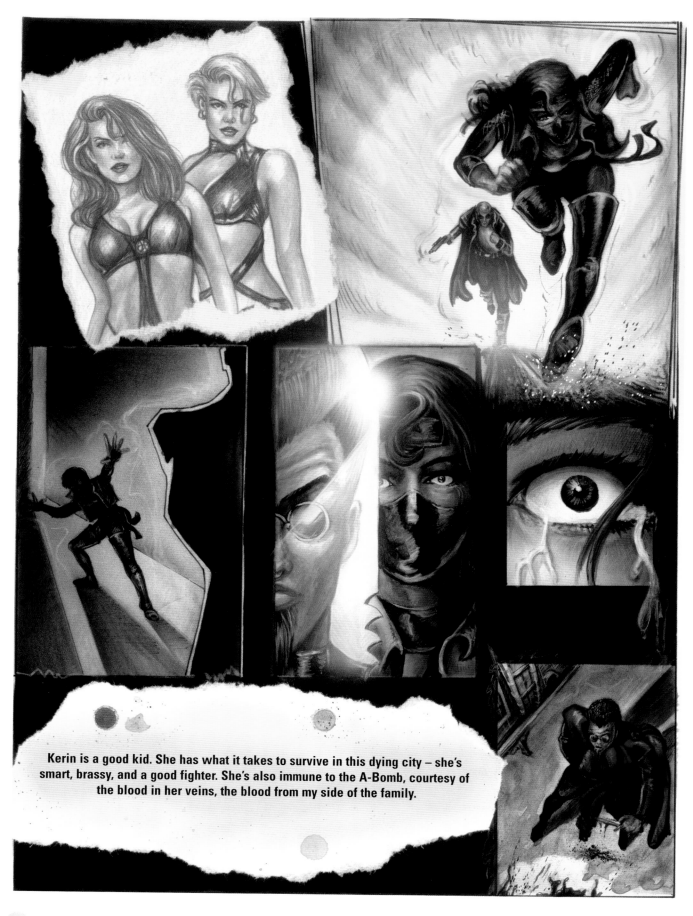

Kerin is a good kid. She has what it takes to survive in this dying city – she's smart, brassy, and a good fighter. She's also immune to the A-Bomb, courtesy of the blood in her veins, the blood from my side of the family.

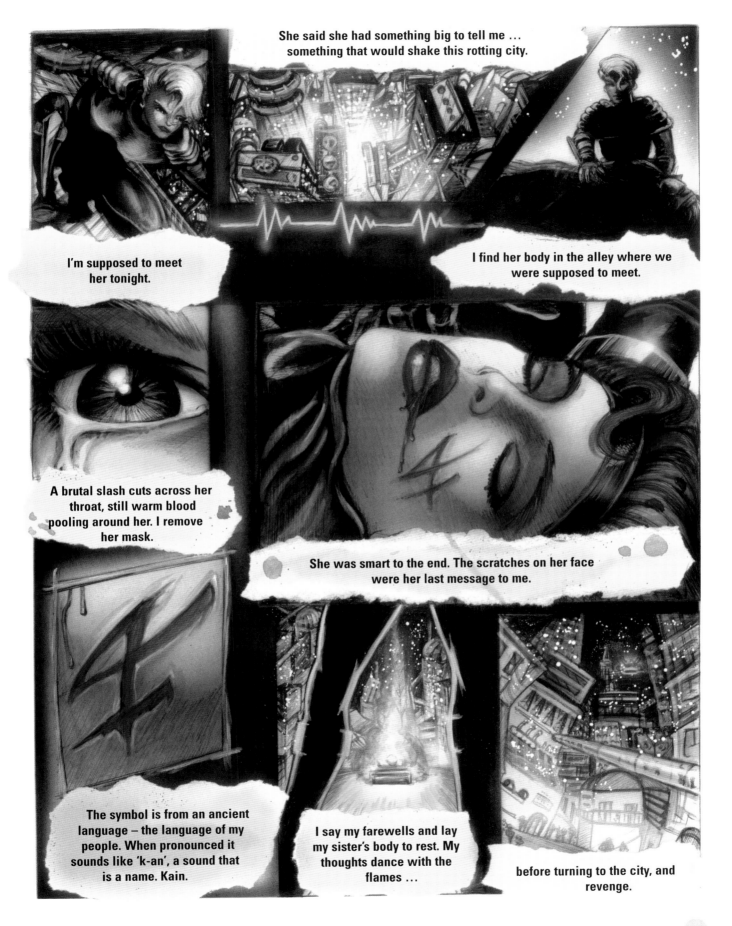

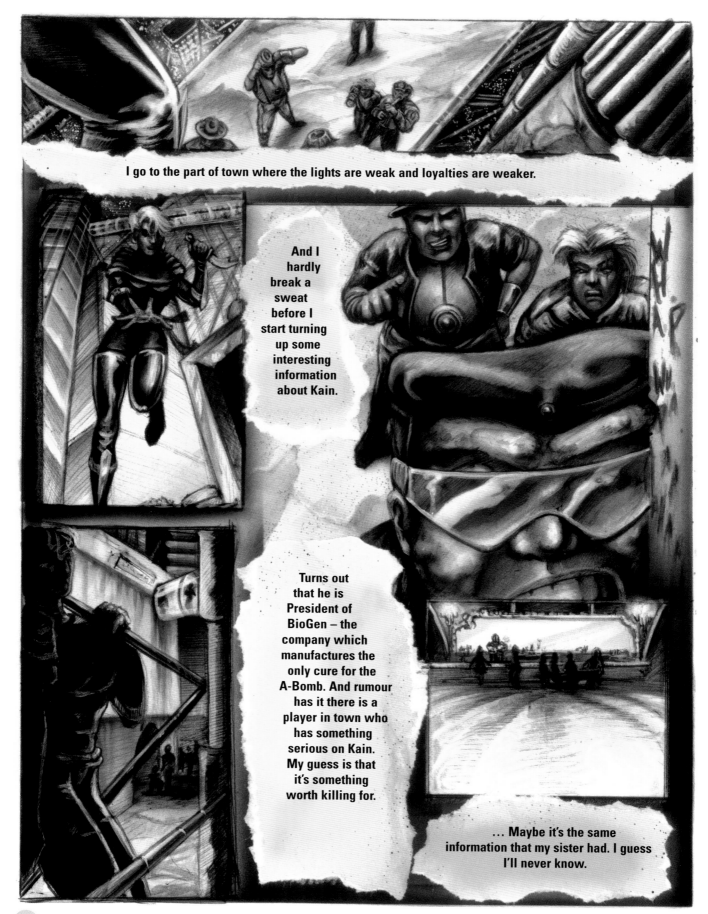

I go to the part of town where the lights are weak and loyalties are weaker.

And I hardly break a sweat before I start turning up some interesting information about Kain.

Turns out that he is President of BioGen – the company which manufactures the only cure for the A-Bomb. And rumour has it there is a player in town who has something serious on Kain. My guess is that it's something worth killing for.

… Maybe it's the same information that my sister had. I guess I'll never know.

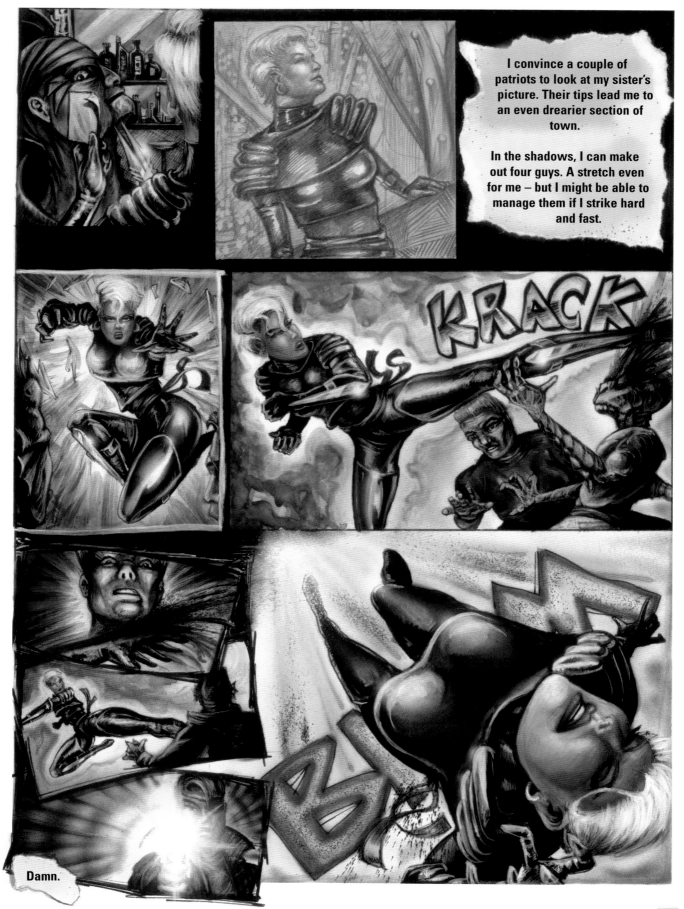

I convince a couple of patriots to look at my sister's picture. Their tips lead me to an even drearier section of town.

In the shadows, I can make out four guys. A stretch even for me – but I might be able to manage them if I strike hard and fast.

KRACK

Damn.

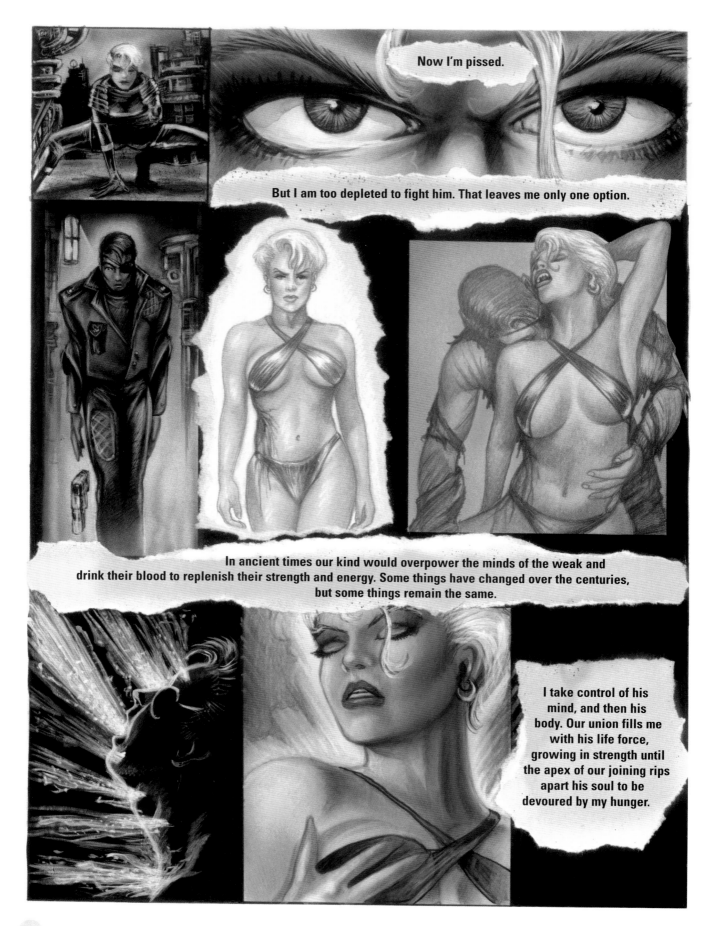

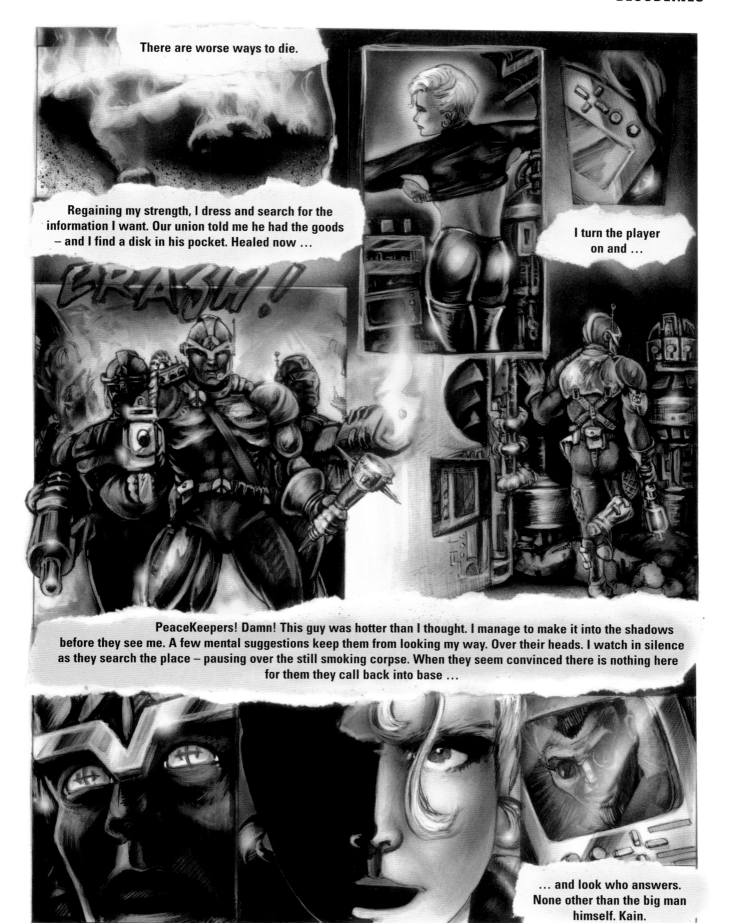

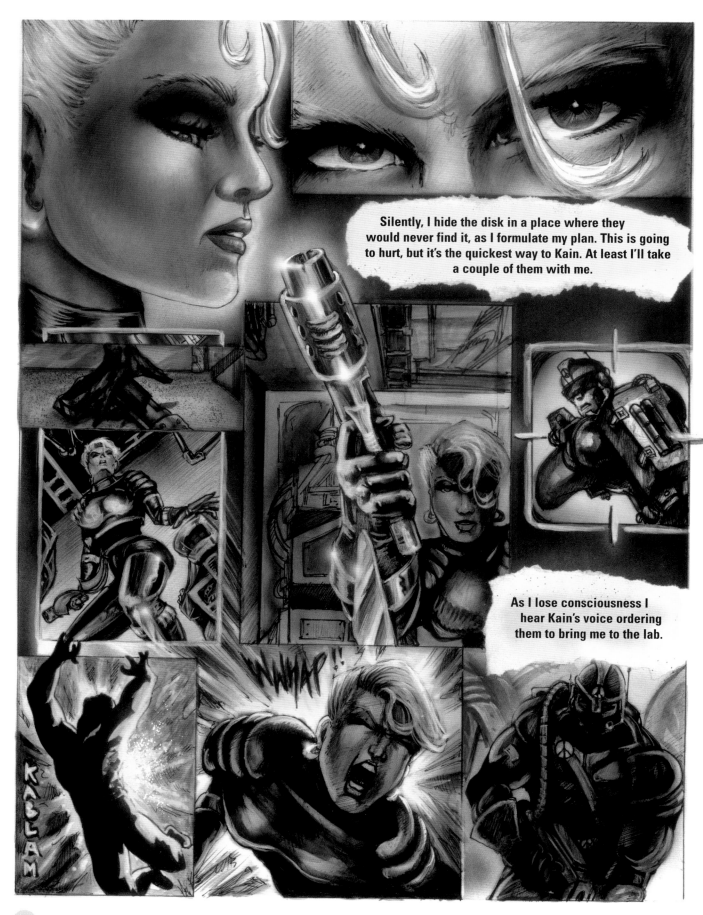

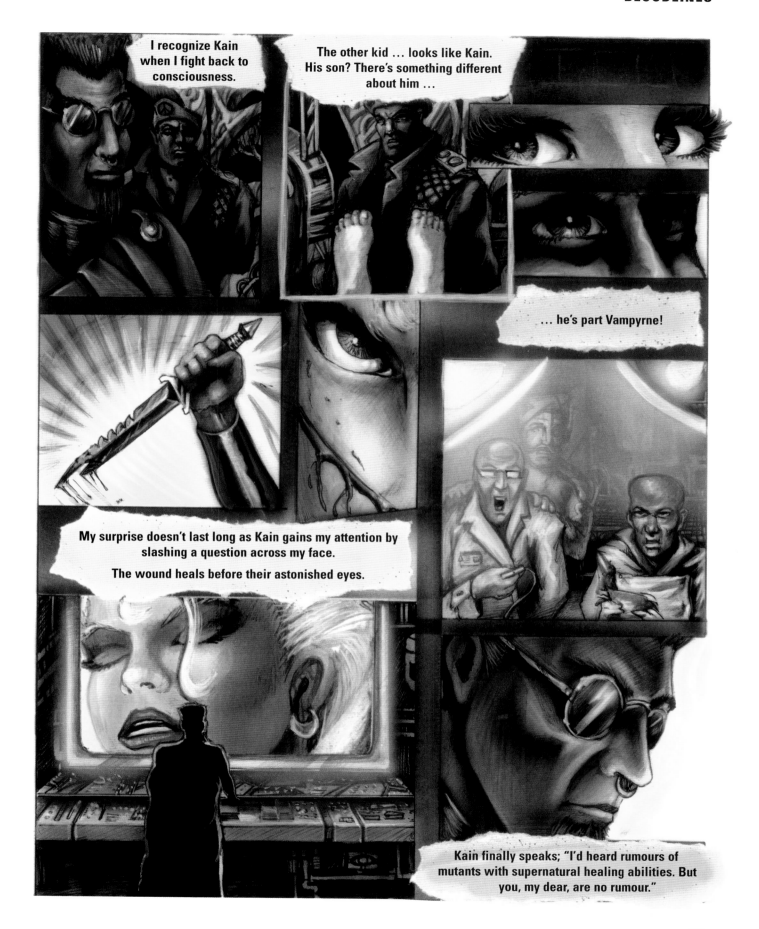

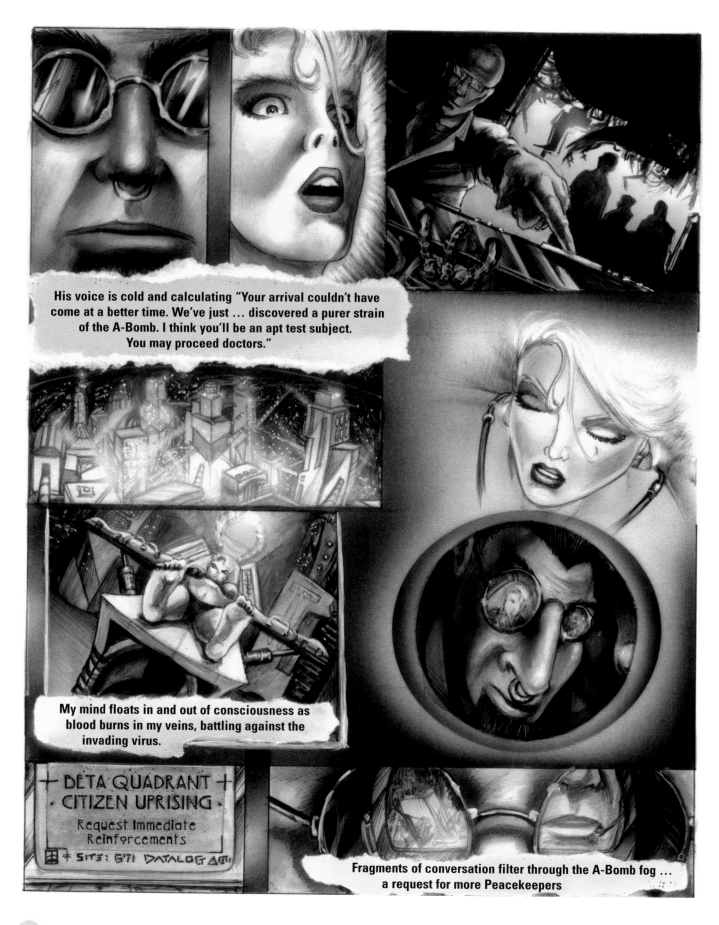

His voice is cold and calculating "Your arrival couldn't have come at a better time. We've just … discovered a purer strain of the A-Bomb. I think you'll be an apt test subject. You may proceed doctors."

My mind floats in and out of consciousness as blood burns in my veins, battling against the invading virus.

+ BETA QUADRANT +
· CITIZEN UPRISING ·
Request Immediate
Reinforcements
+ SITE: 671 DATALOG AO1

Fragments of conversation filter through the A-Bomb fog … a request for more Peacekeepers

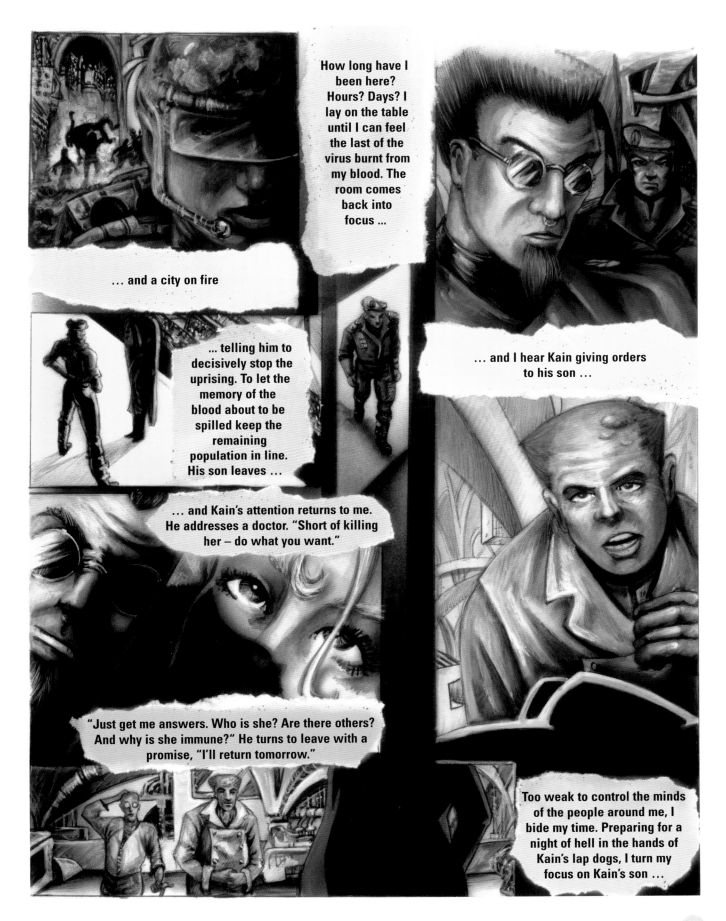

How long have I been here? Hours? Days? I lay on the table until I can feel the last of the virus burnt from my blood. The room comes back into focus ...

... and a city on fire

... telling him to decisively stop the uprising. To let the memory of the blood about to be spilled keep the remaining population in line. His son leaves ...

... and I hear Kain giving orders to his son ...

... and Kain's attention returns to me. He addresses a doctor. "Short of killing her – do what you want."

"Just get me answers. Who is she? Are there others? And why is she immune?" He turns to leave with a promise, "I'll return tomorrow."

Too weak to control the minds of the people around me, I bide my time. Preparing for a night of hell in the hands of Kain's lap dogs, I turn my focus on Kain's son ...

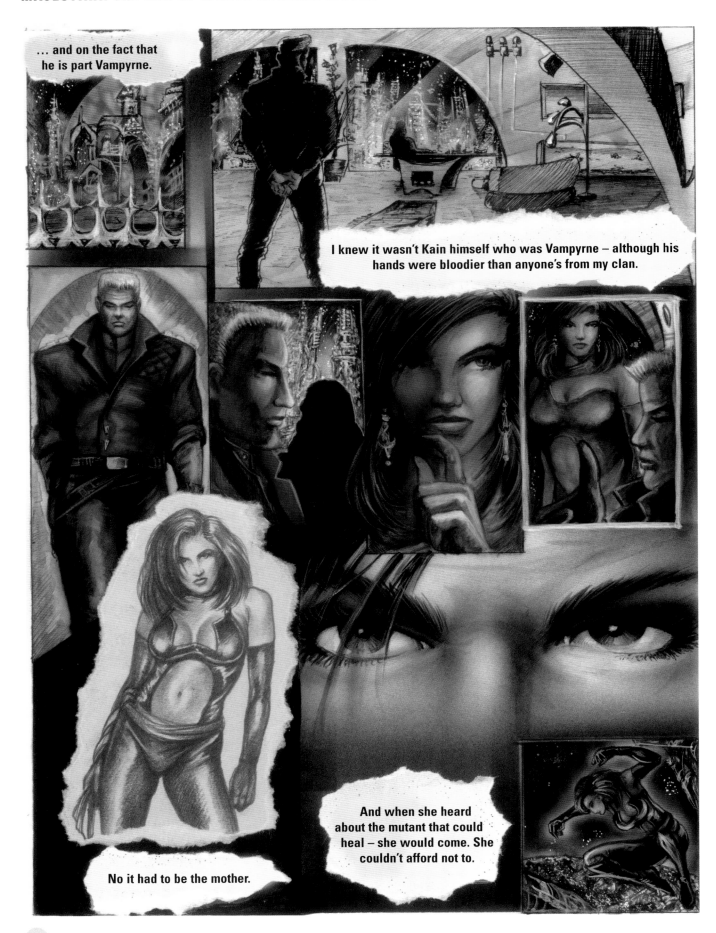

... and on the fact that he is part Vampyrne.

I knew it wasn't Kain himself who was Vampyrne – although his hands were bloodier than anyone's from my clan.

No it had to be the mother.

And when she heard about the mutant that could heal – she would come. She couldn't afford not to.

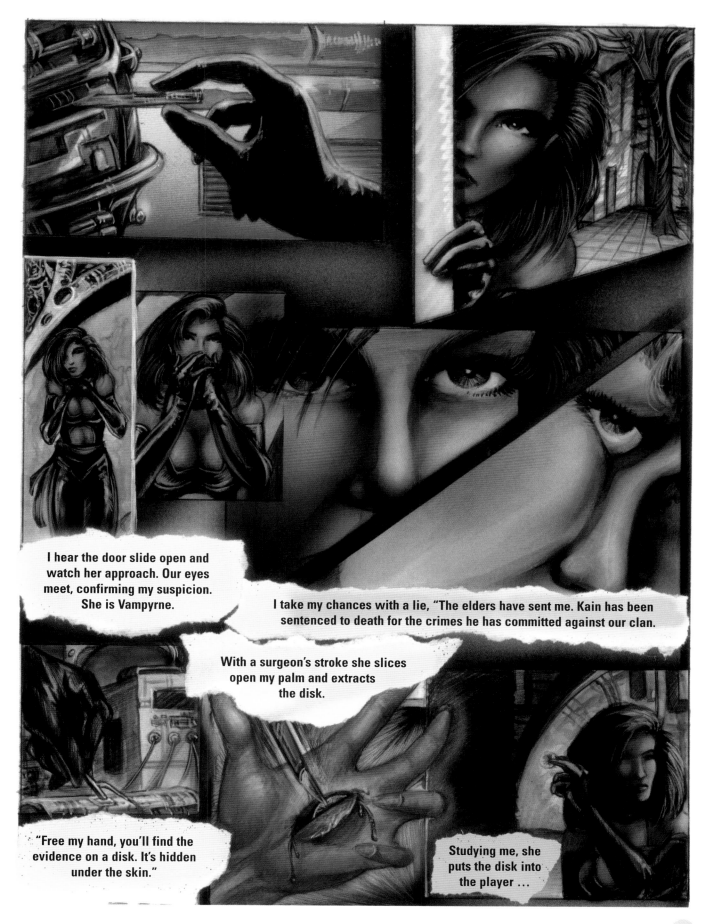

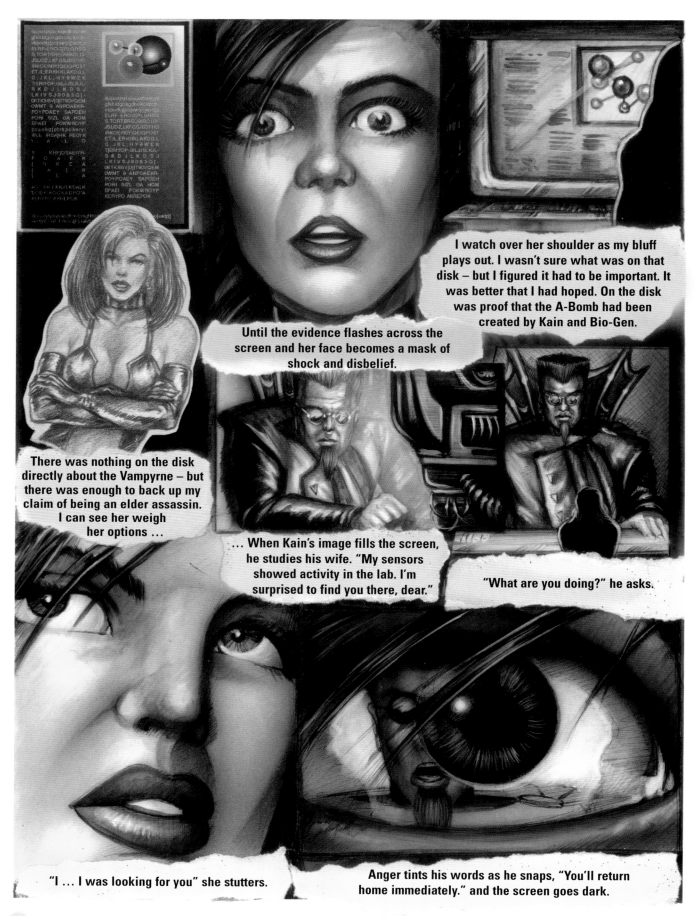

I watch over her shoulder as my bluff plays out. I wasn't sure what was on that disk – but I figured it had to be important. It was better that I had hoped. On the disk was proof that the A-Bomb had been created by Kain and Bio-Gen.

Until the evidence flashes across the screen and her face becomes a mask of shock and disbelief.

There was nothing on the disk directly about the Vampyrne – but there was enough to back up my claim of being an elder assassin. I can see her weigh her options …

… When Kain's image fills the screen, he studies his wife. "My sensors showed activity in the lab. I'm surprised to find you there, dear."

"What are you doing?" he asks.

"I … I was looking for you" she stutters.

Anger tints his words as he snaps, "You'll return home immediately." and the screen goes dark.

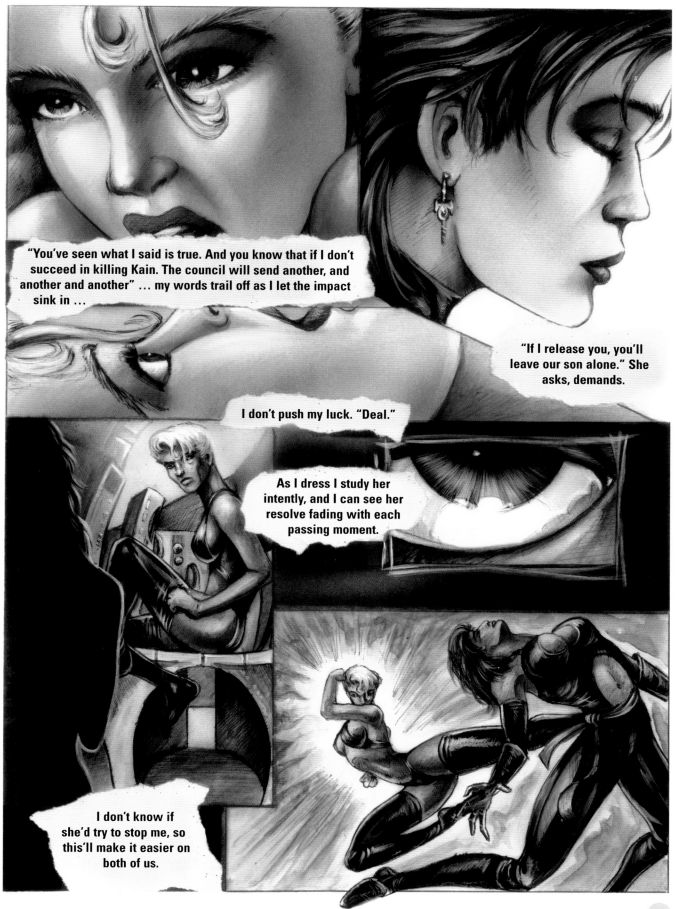

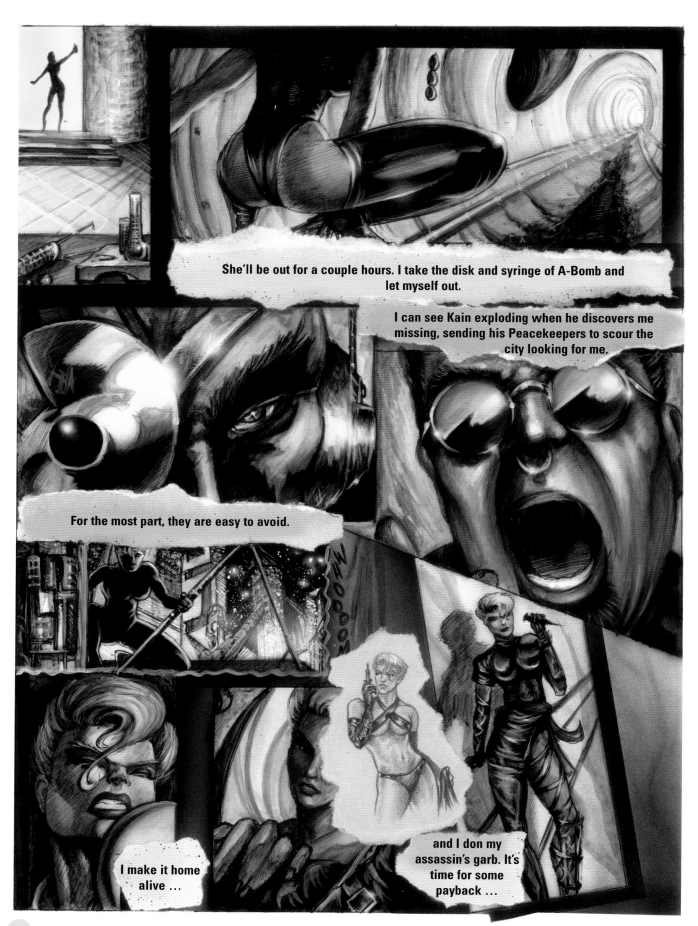

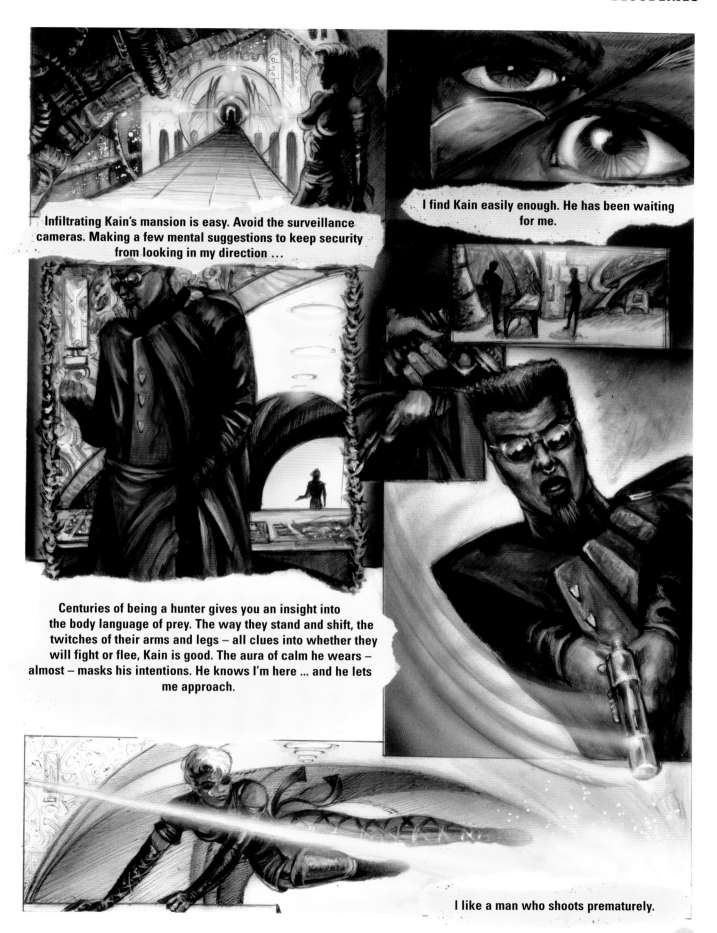

Infiltrating Kain's mansion is easy. Avoid the surveillance cameras. Making a few mental suggestions to keep security from looking in my direction …

I find Kain easily enough. He has been waiting for me.

Centuries of being a hunter gives you an insight into the body language of prey. The way they stand and shift, the twitches of their arms and legs – all clues into whether they will fight or flee, Kain is good. The aura of calm he wears – almost – masks his intentions. He knows I'm here … and he lets me approach.

I like a man who shoots prematurely.

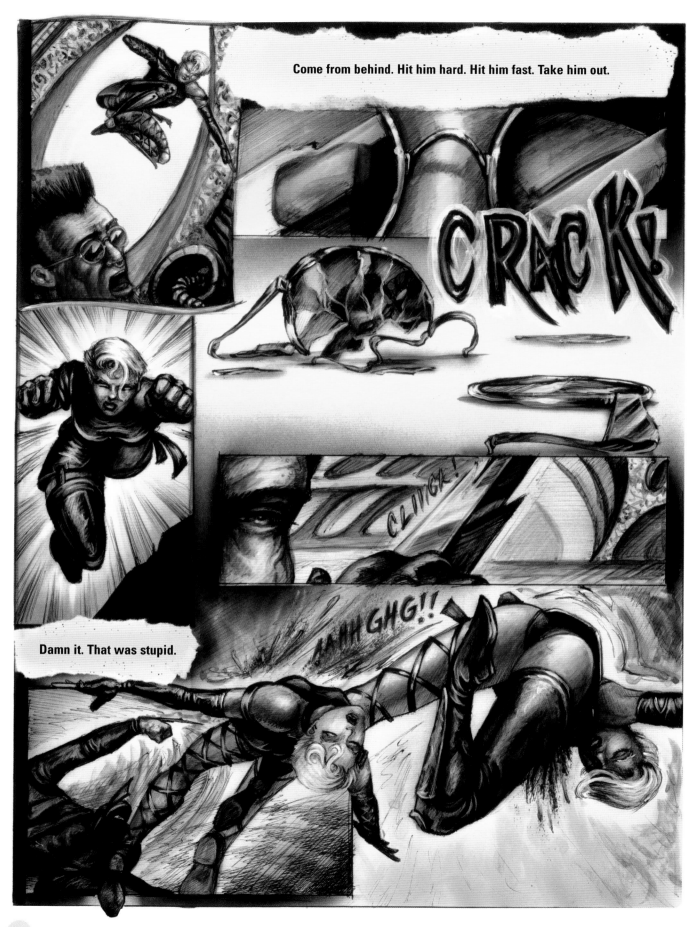

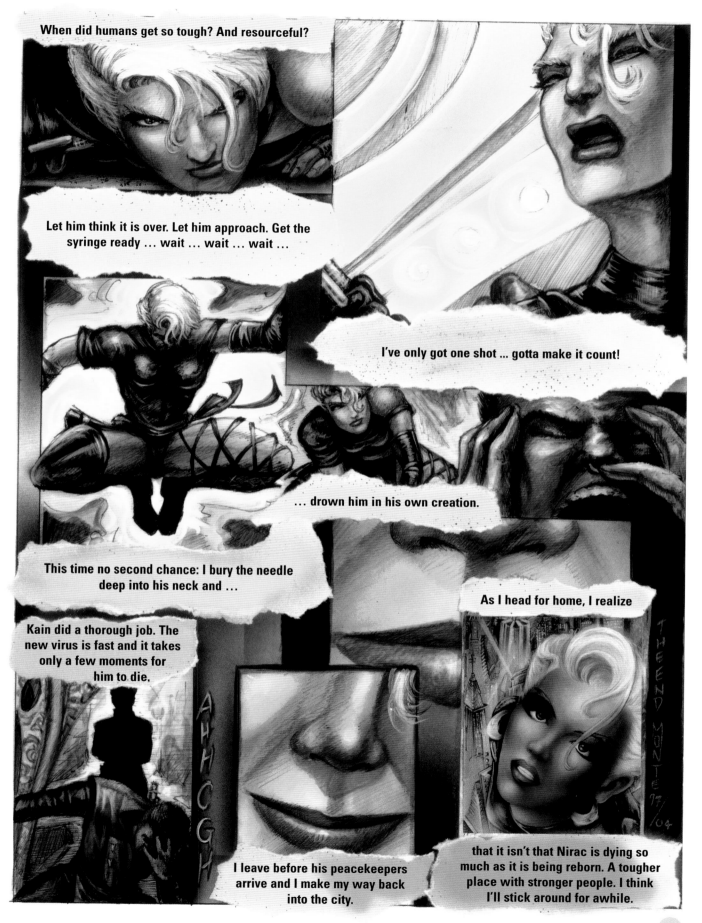

When did humans get so tough? And resourceful?

Let him think it is over. Let him approach. Get the syringe ready … wait … wait … wait …

I've only got one shot … gotta make it count!

… drown him in his own creation.

This time no second chance: I bury the needle deep into his neck and …

As I head for home, I realize

Kain did a thorough job. The new virus is fast and it takes only a few moments for him to die.

I leave before his peacekeepers arrive and I make my way back into the city.

that it isn't that Nirac is dying so much as it is being reborn. A tougher place with stronger people. I think I'll stick around for awhile.

INDEX OF WORKS

ACKNOWLEDGMENTS

A special thanks to all the models who lent their beauty to this body of work.

I would also like to thank Chris Stone at Paper Tiger for his faith in my work; Barbara Donnelly for her excellent legalspeak; Paul Barnett for not allowing me to sound like a moron (a tough task); Christine Richardson for additional wordsmithing; and you, my fans, for helping keep me off the streets by buying this book!

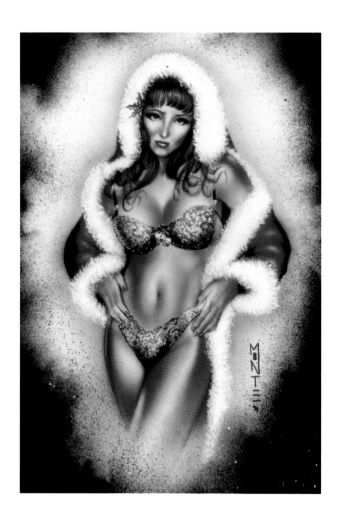